IMAGES
of America

CENTRAL
BREVARD
COUNTY
FLORIDA

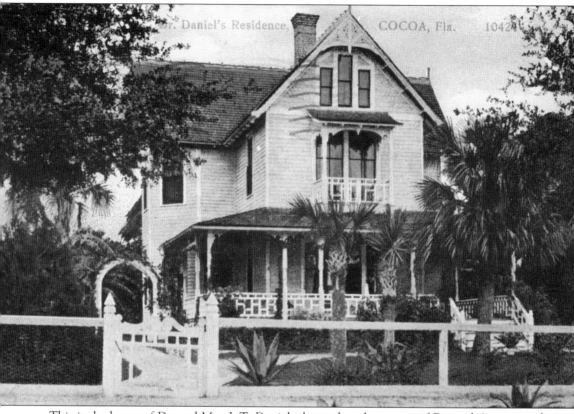

This is the home of Dr. and Mrs. L.T. Daniels, located at the corner of Brevard Avenue and Orange Avenue. The site was used as the location of the 1939 art deco post office building, constructed by the Works Progress Administration (WPA). It is now the location of the Tebeau-Field Library of Florida History.

IMAGES
of America

CENTRAL
BREVARD
COUNTY
FLORIDA

A. Clyde Field, Ada Edmiston Parrish,
and George Leland "Speedy" Harrell

ARCADIA

First published 1998.
Reprinted 2004.

Published by Arcadia Publishing
an imprint of Tempus Publishing Inc.
Charleston SC, Chicago, Portsmouth NH, San Francisco

Printed in Great Britain

Library of Congress Catalog Card Number: 98088260

For all general information contact Arcadia Publishing at:
Telephone 843-853-2070
Fax 843-853-0044
E-mail sales@arcadiapublishing.com
For customer service and orders:
Toll-Free 1-888-313-2665

Visit us on the internet at http://www.arcadiaimages.com

CONTENTS

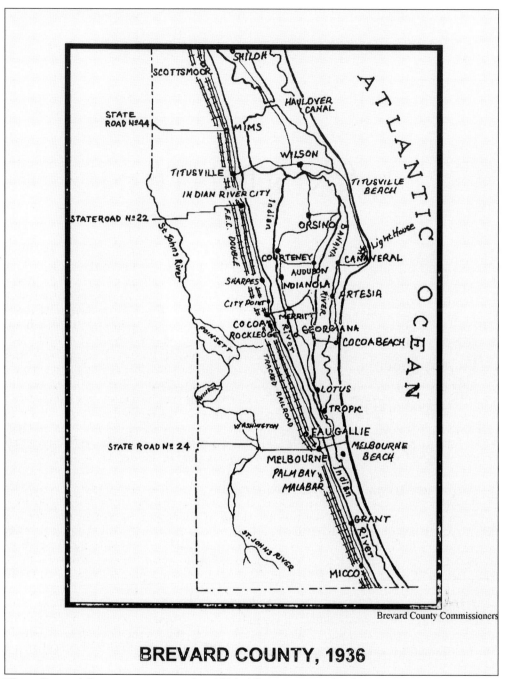

BREVARD COUNTY, 1936

This is Brevard County as it appeared in 1936. All or portions of Indian River County, St. Lucie County, Osceola County, Seminole County, and Orange County were carved from "Mosquito County," which was the original name of the Indian River area.

INTRODUCTION

The great Indian River Lagoon, a broad body of water that stretches almost 150 miles along Florida's east coast, was one of the last frontiers of the "Sunshine State." Although some local historians argue that Ponce de Leon landed near present-day Melbourne Beach and although Cape Canaveral, the oldest recorded place name on North American maps, is part of the Indian River geographical area, settlement of the region was slow. Originally known as Mosquito County, the boundaries of Brevard County extended to Lake Okeechobee to the south and Kissimmee to the west. As late as 1870, the census reported that a mere 225 people lived between Titusville, near the northern end of the Indian River Lagoon, and present-day Miami. To say that this almost 150-mile stretch of land on Florida's east coast was thinly populated was not an understatement. Formidable barriers existed to settlement. To the east, salt marshes provided excellent breeding grounds for millions of mosquitoes, which made human occupation difficult at best and impossible at the worst. To the west, the headwaters of the mighty St. John's River presented similar barriers to settlement. Only a thin strip of land along the banks of the Indian River and the islands were habitable on a permanent basis. The region's abundant wildlife attracted numerous hunters and fishermen, but most of these came for only brief visits during the cooler months of the year.

Despite the difficulties, a few hardy men and women staked their future on carving out homes in this wilderness. Tied in a loose association by the Indian River, these folks struggled to survive and to prosper. When the first steamboat was launched on the lagoon in 1877, the area was thrust into Florida's cultural, political, and economic mainstream. Tourism and commercial agriculture, along with cattle ranching, provided a dependable source of income for residents. What had been a subsistence existence for most families now offered great prosperity with the construction of resort hotels and the cultivation of citrus, pineapples, truck crops, and other more exotic crops.

When the first railroad arrived in the 1880s, the economic boom continued. By the 1920s, automobiles and paved roads brought thousands of "land boomers" to Brevard County, while thousands more came as a result of World War II. Finally, the advent of the space program in the 1950s and the rise of the Disney complex in Orlando brought hundreds of thousands of new arrivals seeking the stars and the sunshine.

Today's central Brevard County still retains much of its early character. This photographic essay captures the essence of the past and the promise of the future.

ACKNOWLEDGMENTS

This book would not have been possible without the support and contributions of the following people. In addition, numerous unnamed others suggested ideas and sources for pictures. Thank you all.

Norris Andrews Bliss, Ann Akridge Bonner, Grace Packard Bryant,
Minnie Whittington Hargrave Butler, Hollace Chastain,
Jane Headley Dixon, Roger Dobson, Dorothy Ellington,
Lois Dixon Gray, Ira Hill, Fred A. Hopwood,
Marion Paterson Jackson, Ed Patrick, Lois Pierce,
Charlie Provost, Joyce Roth, Elsie Smith,
Sandy Solvick, Dora Ann Thompson, Marlene Minella Wells

The Central Brevard Mosquito Beaters made their photographic archives available to us and encouraged us to proceed with this volume. The volunteer staff of the Tebeau-Field Library of Florida History assisted in a variety of ways, and any proceeds from the sale of this book will go to support the Library.

A. Clyde Field
Ada Edmiston Parrish
George Leland "Speedy" Harrell
Cocoa, September 11, 1998

One
COCOA AND ROCKLEDGE

Central Brevard County, centered around the small towns of Cocoa and Rockledge, was one of the most prosperous areas of the Indian River region. The busy commercial life of Cocoa gave rise to substantial public buildings and stores, while the upscale resort hotels along the river in Rockledge provided a core to its developing residential areas. Only a mile or so separated the towns originally, and that separation has long disappeared as the two towns grew. Although they are still politically separated today, citizens of each town freely identify with each other, patronizing the same churches, schools, and businesses.

The construction of a bridge across the Indian River in 1916–17 allowed for safe and speedy transit to Merritt Island. There is no political entity of "Merritt Island," but residents of this island between the Indian River and Cocoa Beach have a sense of distinctiveness. Like the residents of Rockledge and Cocoa, they come together to contribute to the totality of central Brevard County. So, too, do the residents of Cocoa Beach, which was the 1920s brainchild of Cocoa lawyer and entrepreneur Gus Edwards. Central Brevardians see themselves as members of small and distinctive communities, welded together into a larger, homogeneous whole.

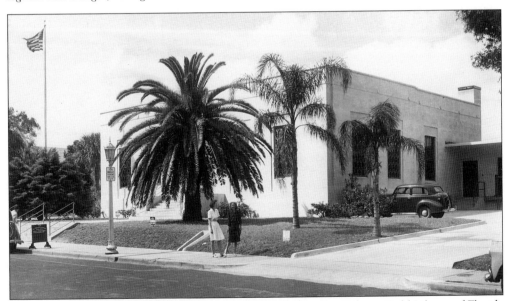

The Cocoa Post Office, built in 1939 by the WPA, is now the Tebeau-Field Library of Florida History. It also houses the administrative offices of the Florida Historical Society, the Brevard Heritage Council, and the "Mosquito Beaters," a local community reunion group. Teresa (Heilman) Eschbach and Betty Ann (Hubble) Smith are pictured out front.

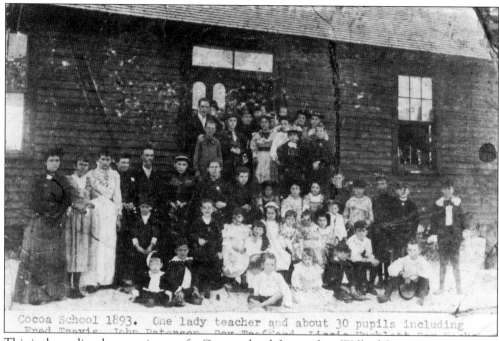

Cocoa School 1893. One lady teacher and about 30 pupils including
Fred Travis. John Paterson. Roy Trafford. Lizzie Hughlett. Roy Packard.

This is the earliest known picture of a Cocoa school. Located on Willard Street, west of Forrest Avenue, the school had one female teacher and about 30 pupils. Included in this early picture are well-known community pioneers Fred Travis, John Paterson, Roy Trafford, Lizzie Hughlett, and Roy Packard.

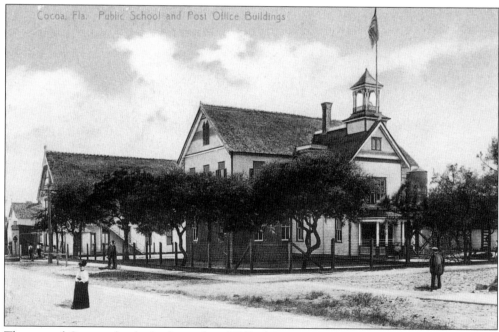

Cocoa, Fla. Public School and Post Office Buildings

The second Cocoa school, also located on Willard Street, east of Forrest Avenue, was a much more modern building and represented the growing affluence of Cocoa as a center of Indian River commerce (c. 1900).

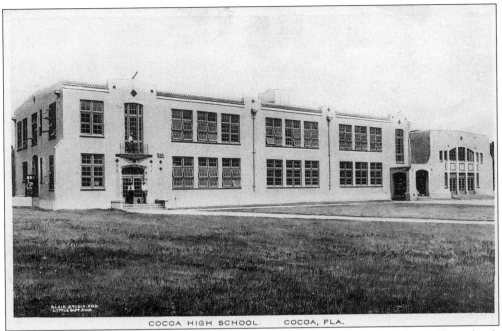

This is the first Cocoa High School built as a separate facility for upper grades. Earlier schools contained all grades from the first through high school. This building was later converted into an elementary school when a new three-floor high school was constructed. It was located on Forrest Avenue in the area of Mitchell and Parkway Streets.

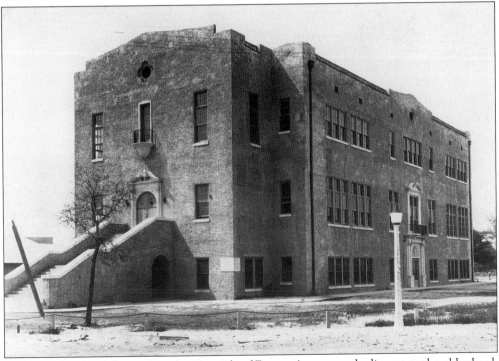

Cocoa High School, located on the west side of Forrest Avenue and adjacent to the old school, saw many generations of central Brevardians pass through its doors.

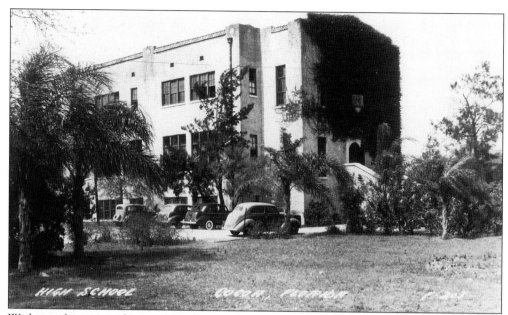

Within a few years after its construction, Cocoa High School became a true "ivy-covered" tower of education. The vine (pictured on the end of the building) was not really ivy, but a vine that produced an inedible fruit about 1 inch wide and 1.5 inches long. Rambunctious students took great delight in lobbing the fruit at each other during breaks. The vine completely covered the opposite side of the building.

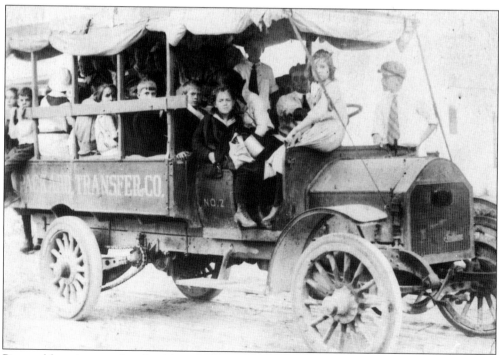

Pictured here is an early school bus in Cocoa. Roy Packard, shown on p. 10 as a student at a Cocoa school, owned this vehicle and was paid to transport students.

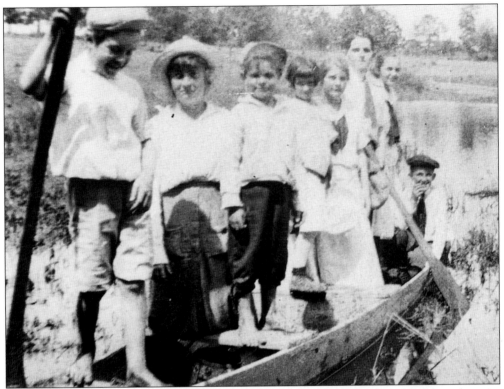

Here was another way to go to school. Some children on Merritt Island or along the tributaries of the Indian River came to school in a boat or via the mail steamers that served these isolated areas.

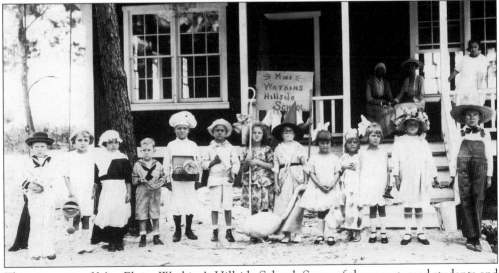

This picture is of Miss Elvira Watkins's Hillside School. Some of these costumed students and teachers have been identified. They are, from left to right, as follows: (front row) James Curwen, unknown, Hazel Shelton, ? Trussler, James Edwards, Henry Maxwell, Frances Porcher, Doris Risk, unknown, Betty Sweet Smith, Dottie Brown, unknown, and Jimmy Lincoln; (back row) Grandma Watkins, Ada Spiller, and unknown.

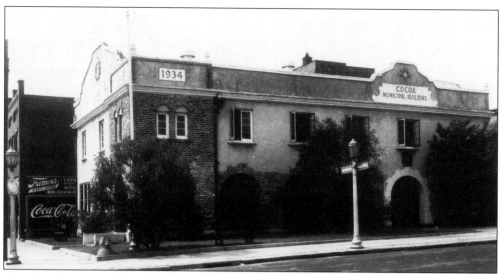

The Cocoa Municipal Building housed city offices on the street floor, while civic groups and service clubs used the second floor. School dances were also held there. During World War II, the second floor became the headquarters of the Civil Defense agency. Note the Egyptian sphinx sculpture at the street corner. This was one of a pair crafted from native coquina rock.

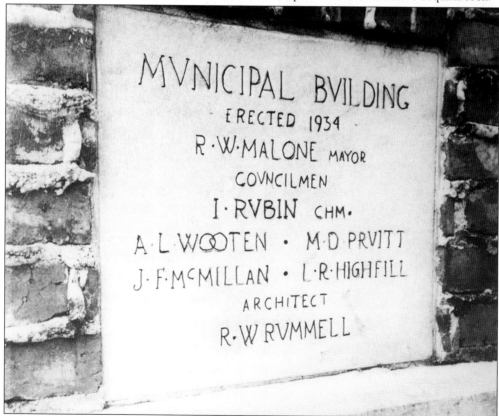

This is the Municipal Building cornerstone. The architect, R.W. Rummell, was famous locally for his designs of Mediterranean Revival homes built during the Florida boom.

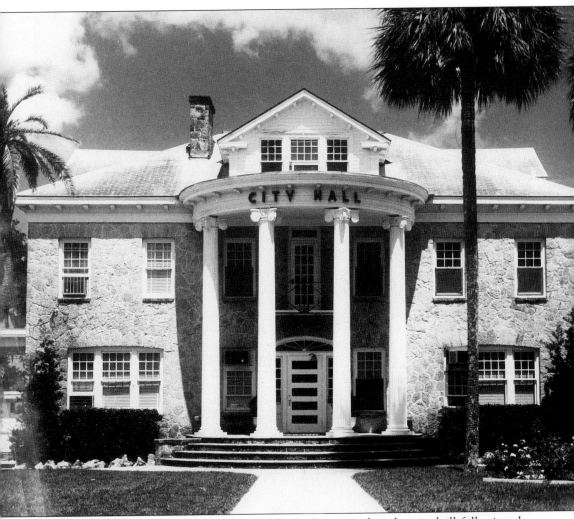

The Porcher House, now a multiple-use public facility, served as the city hall following the demolition of the Cocoa Municipal Building.

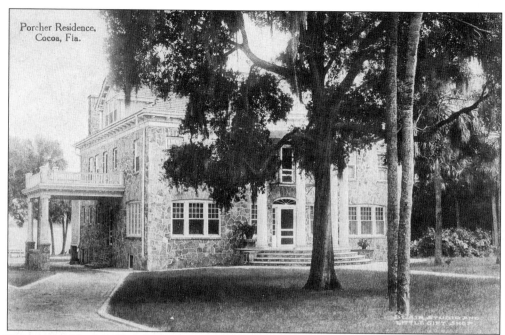

Here is the Porcher House as it appeared in 1920. Built in 1916 by the E.P. Porcher family, wealthy citrus and cattle brokers, the house is constructed of native coquina and features a design of playing card suits carved in the rock along the eaves of the house.

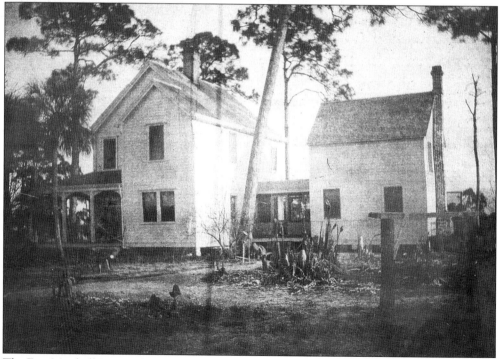

The Ezra Marshall Breese House, completed in 1888, featured a separate kitchen. This was done to provide a margin of safety in case of fire and to keep the heat of wood stoves away from the family's living quarters.

The family of Dr. W.L. Hughlett, the first mayor of Cocoa following its incorporation in 1895, occupied this stately home at the corner of today's Brevard Avenue and Church Street. Unfortunately, the house is no longer standing.

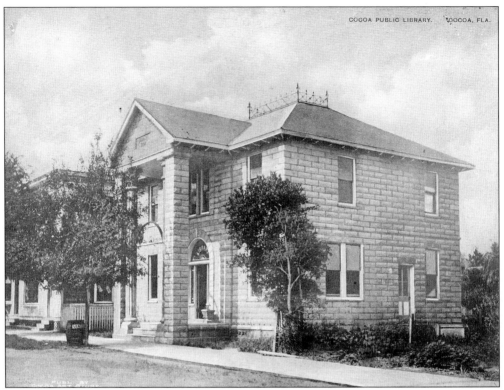

This well-constructed building served Cocoa residents as their public library for a number of years.

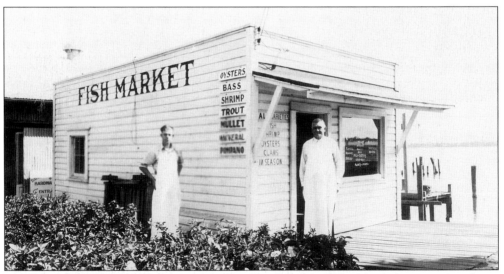

The Worley Fish Market on Harrison Street offered a variety of seafoods for Cocoa residents. "Tal" Worley (left) and Ed Harding (right) were well-known figures who catered to the Epicurean demands of the populace. The market was later sold and continued to operate for a number of years as Fischer Seafoods.

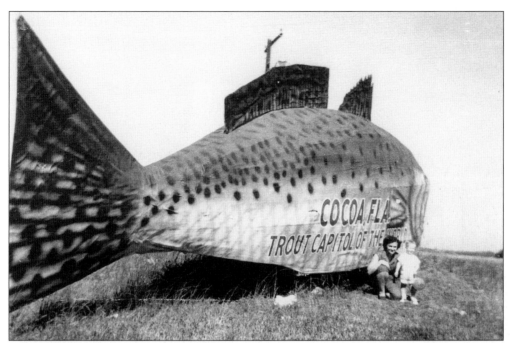

This float appeared in many central Florida parades. Mayor Gary Bennett touted Cocoa as the "Salt Water Trout Capitol of the World." A continuing argument arose over whether the mayor had misspoke and that Cocoa was the "Salt Water Trout *Capital* of the World." Brian Lott and his mother, Jean, are pictured beside the float in 1955.

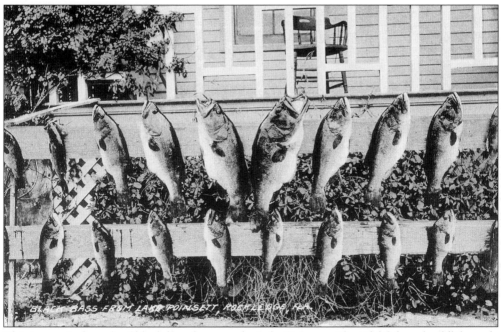

This is a typical catch of black bass from nearby Lake Poinsett. Plentiful fish and wildlife made central Brevard County a sportsman's paradise.

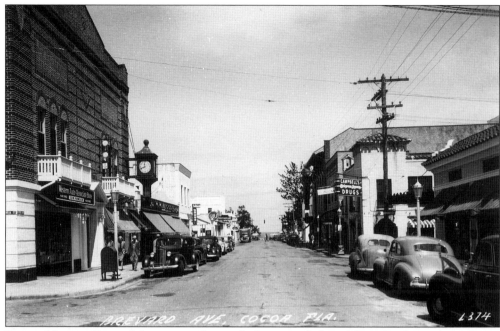

Pictured here is Brevard Avenue in Cocoa, looking north from Magnolia Street (now Stone Street). The large clock on the Masonic Temple was erected in the early 1920s and removed by the City of Cocoa in the 1950s. It was later sold for the value of the scrap brass it contained. Some local enthusiasts are hoping the city will erect a replacement clock.

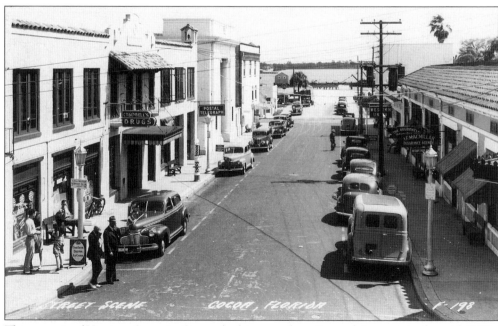

This scene is of Harrison Street in Cocoa, looking east from Brevard Avenue, in the mid-1940s. The Postal Telegraph office (left) and the Western Union office across the street had thriving businesses in this era before fax machines and e-mail.

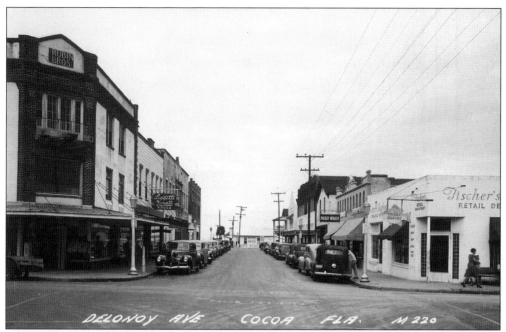

In the mid-1940s, Delannoy Avenue (shown looking north from Harrison Street) was a busy hub of commerce. Rubin Brothers, the large department store on the left, carried all the latest fashions.

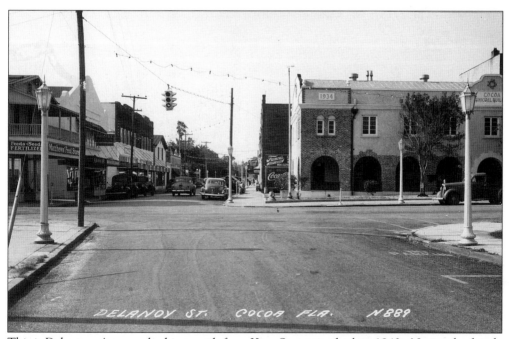

This is Delannoy Avenue, looking south from King Street, in the late 1940s. Notice the facade of the Cocoa Municipal Building. Today's Travis Hardware, the oldest continuously operating commercial enterprise in Brevard County, is the second building on the left.

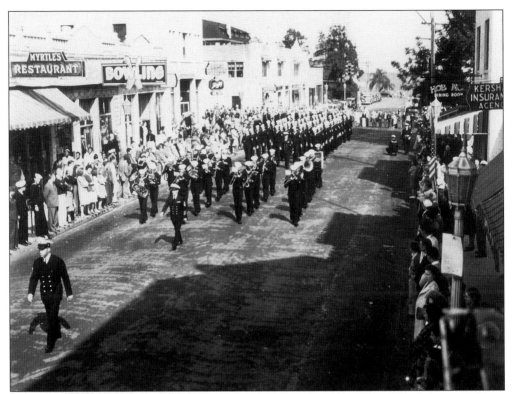

The Banana River Naval Air Station Band parades down Brevard Avenue during the early 1940s. Myrtle's Restaurant, shown on the left, is not be confused with the later Myrt's.

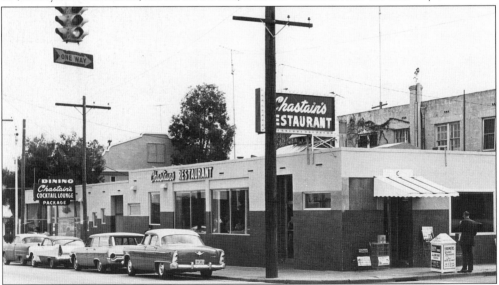

Chastain's Restaurant, on the southeast corner of King Street and Brevard Avenue, was built about 1961. Prior to its construction, the lot was occupied by a large chinaberry tree. During WW II, a lifeboat from a ship that had been torpedoed off the coast of Cocoa Beach was on display here. The boat was riddled with holes from German machine guns. It was reported that 12 men were killed in the boat (see p. 127).

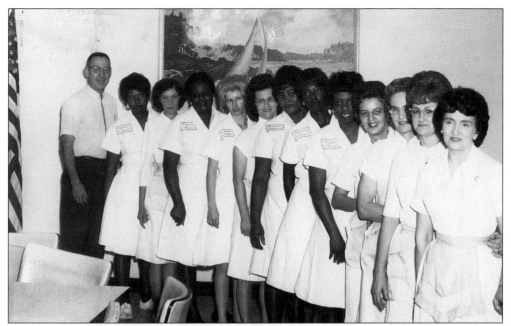

Hollace Chastain is shown in this 1967 photograph with his restaurant staff. From left to right, they are Hollace Chastain, Sylvia Jenkins, Mary Ann Gannon, Rosebud Blackman, Dollie Ray, Ann Bellflower, Julia Horne, Ruby Williams, Betty Banks, Bettie Kramer, Francis Kyle, Pearl Ferris, and Faye Willis Richie.

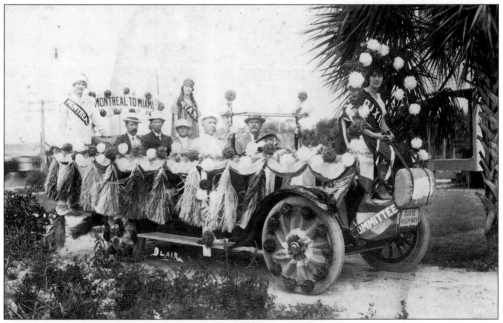

This is a float in a parade celebrating the opening of a portion of the Dixie Highway. The tires on this car are solid rubber. The aim of the builders of the Dixie Highway was to provide a paved road from "Montreal to Miami." The men in the front seat are Charlie Tarter and Ed Grimes. Bill Myers, Roy Packard, and Gus Thomas occupy the back seat. The young ladies are Anita Travis, Arlene Wooten, and Maude Hindle.

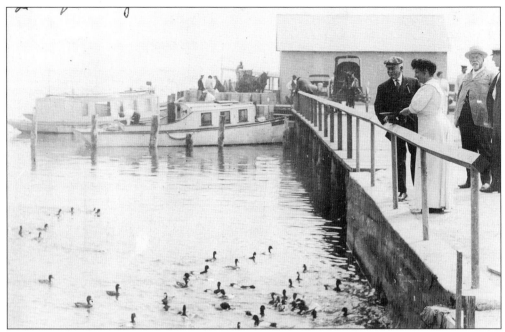

This 1910 picture captures a crowd of local residents engaging in the popular pastime of feeding the ducks at the edge of the Indian River. The gentleman second from the right is "Chief" Nevins, the retired fire chief from New York, who established the Nevins Fruit Company, a local citrus farming concern.

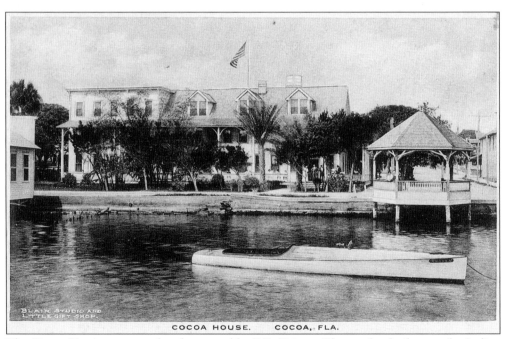

COCOA HOUSE. COCOA, FLA.

The Cocoa House was owned and operated by E.E. Grimes. The gazebo, built over the Indian River, was a landmark for visitors for many years. The drive-in window of the Sun Trust Bank of Cocoa now occupies the site of this once-popular hotel.

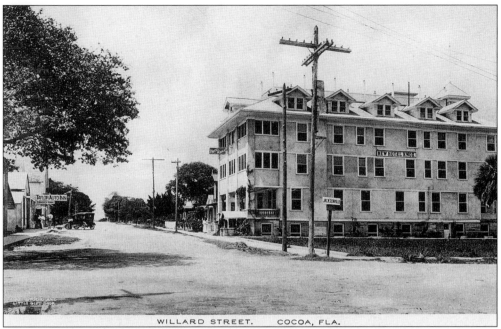

WILLARD STREET. COCOA, FLA.

Ames A. Barlow of Galesburg, Illinois, built and operated the Knox Hotel on Willard Street. It survived one fire, but was later demolished by another fire. An entrepreneur put a roof on over the basement and operated a bar on the site. Barlow was an active civic leader and a participant in the Florida boom of the 1920s. In 1922, he offered lots for sale in the Barlow Subdivision west of town.

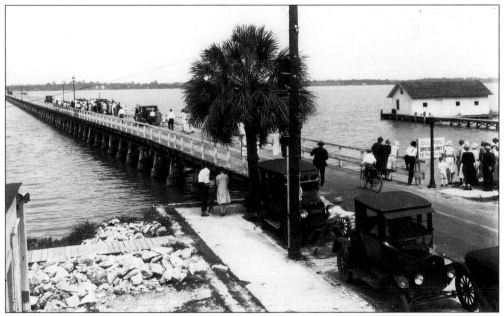

In 1917, the first bridge to span the Indian River opened between Cocoa and Merritt Island. The bridge, built at a cost of $70,000, was made of wood. Local daredevils prided themselves on how fast they could cross the bridge in reverse at night. Opening day ceremonies brought out a large crowd of local residents.

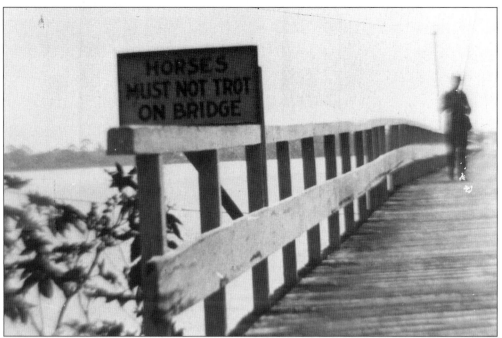

This sign, posted at the entrance of the 1917 bridge, warned that "Horses Must Not Trot on Bridge."

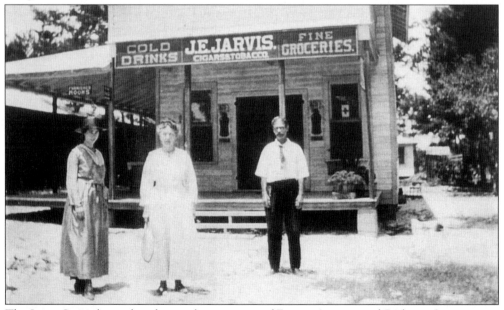

The Jarvis Store, located at the northeast corner of Forrest Avenue and Parkway Street, was a popular stopping place for students at the schools located to the west. The Jarvis family had a reputation for patience in dealing with children with limited funds and large appetites for the candies on the counter. Paramount in the selection process was the consideration that one penny had to be saved to use on the movie machine. The machine, which was operated by a crank, featured a short, unchanging movie that was viewed over and over again with each visit to the store.

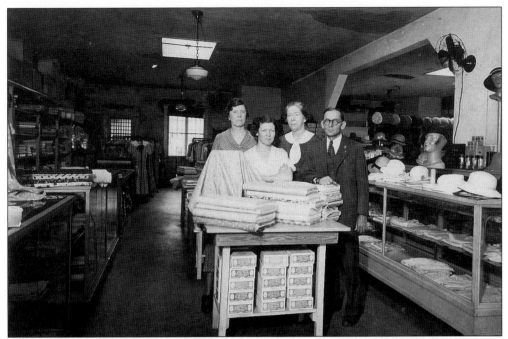

Early residents of central Brevard frequently shopped the various "trade" boats that plied the Indian River. With the construction of the bridge across the river, residents could take advantage of "in-town" shopping at such establishments as Swans Dry Goods Store (later Alderman's Dry Goods Store) in Cocoa. Here, proprietor Flave Alderman is pictured with his wife (to his right) and sales associates Lillie Thompson Dean and Eileen Paul. This was obviously the "place to go for your Easter finery."

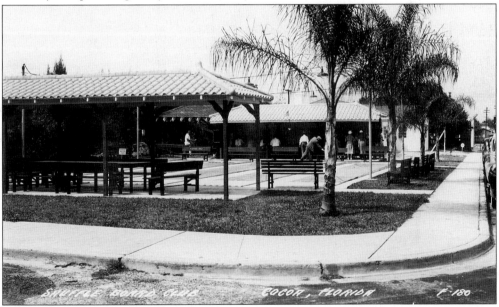

The Cocoa shuffleboard courts were originally located at the corner of Orange Street and Brevard Court, the site of Cocoa's current post office. In the early 1960s, these popular courts were moved to Harrison Street near the Indian River.

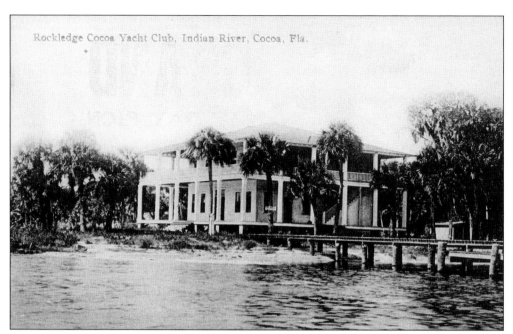

Rockledge Cocoa Yacht Club, Indian River, Cocoa, Fla.

The Rockledge-Cocoa Yacht Club was located on Oleander Point in Cocoa. Oleander Point was a popular meeting place for early Indian River settlers, particularly for their May Day celebrations. Settlers would come from as far away as Jupiter Inlet (130 miles) for this event.

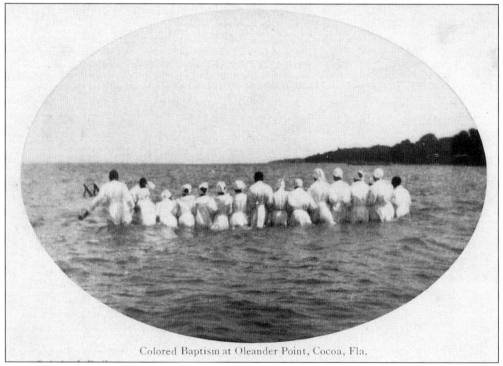

Colored Baptism at Oleander Point, Cocoa, Fla.

Oleander Point, now occupied by the Oleander Pointe condominiums, was a popular site for early baptisms in Cocoa. The Baptists and the African-Methodist Episcopal churches used the site for this purpose as late as the 1950s.

The annual May Day festivities held at Oleander Point provided several days of sporting, courting, and social events. One local resident reported that the May Day activities were "absolutely essential to the continued population growth of the Indian River area." Isolated young people reveled in this opportunity to meet members of the opposite sex.

GRAND

MAY DAY PICNIC

AT COCOA, FLORIDA, ON

TUESDAY MAY 3RD

PROGRAM

10 A. M. Base Ball Game

12 M. Dinner

1 P. M. Boat Race

2:30 P. M. Gun Shoot

OTHER SPORTS DURING THE DAY

Water Base Ball, Blind Folded Pig Hunt, Tub Race, Potato Race, Shoe Race, Boys' Foot Race, Girls' Foot Race.

Dance at the Club House in the evening at 8:30. Admission, Gentlemen $1.00; Ladies free. The Fort Pierce Band will play during the afternoon, and orchestral music at the dance

A feature of the day will be the Ball Game between the fast team from Fort Pierce and a team from Cocoa. Game called at 10 o'clock a. m. sharp. Hacks will meet boats at City Dock to take parties to grounds.

The picnic will be held at Oleander Point as usual

Coffee, Sandwiches and Fish Will be provided Free

As many as can conveniently do so, are requested to bring along their baskets with dinner, and help to make this a good old time picnic and day of enjoyment for old and young.

HALF FARE ON THE FLORIDA EAST COAST RAILWAY

From Daytona, Sanford, Fort Pierce, and all

Intermediate points from 2nd till 4th of May.

Do not miss this opportunity to meet old friends, see Cocoa, hear the famous Fort Pierce Band and forget your troubles for one day.

BRING THE WIFE, BABIES AND SWEETHEARTS

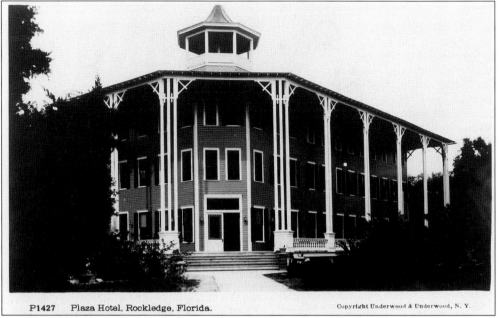

By the late 1890s, Rockledge had gained an international reputation as a winter resort. Three large hotels stood on the coquina banks of the Indian River. The Plaza Hotel was located at the corner of Rockledge Drive and Valencia Road. Unfortunately, the hotel is no longer there, and the site is now a parking lot for Rockledge Presbyterian Church.

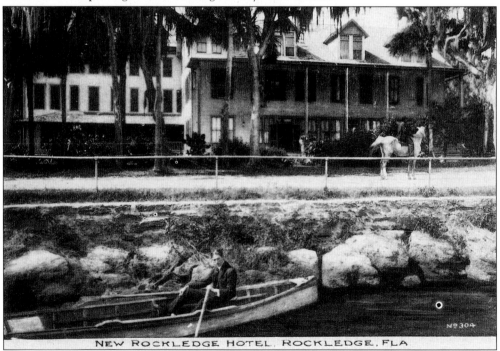

NEW ROCKLEDGE HOTEL, ROCKLEDGE, FLA.

The New Rockledge Hotel was another of the famed "Indian River Ladies," which catered to the rich and famous of another era. The rural landscape and the plentiful wildlife provided an idyllic setting for vacationers.

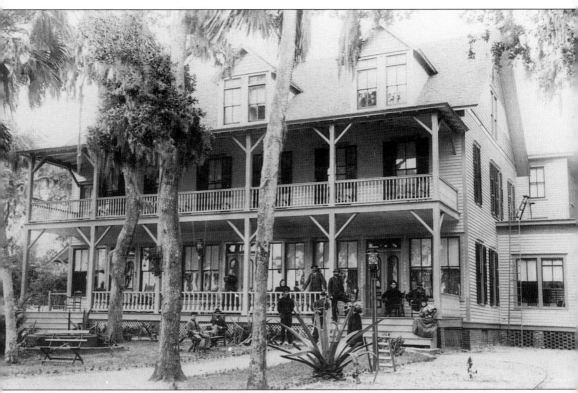

This is a view of the Rockledge Hotel with guests enjoying themselves on the front porch. The woman at the foot of the steps is holding a rifle, while a young man in a military cadet's uniform sits on a bench to the left.

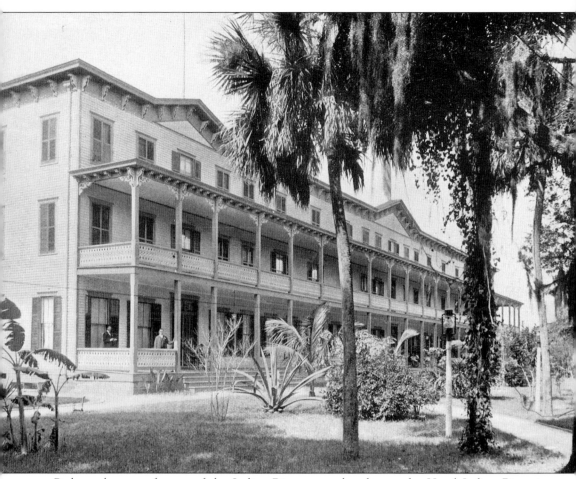

Perhaps the most famous of the Indian River resort hotels was the Hotel Indian River in Rockledge. The spacious accommodations were surrounded by pleasant gardens, while the peaceful Indian River offered a restful scene for those who were inclined to sit and rock on the front porches.

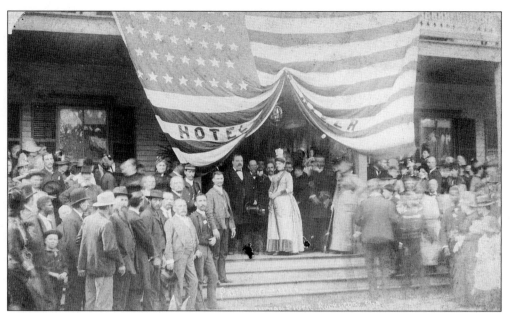

President Grover Cleveland and his new bride, the former Frances Folsom, visited Rockledge and the Indian River Hotel in the early 1890s. A legion of admirers was on hand to greet the newlyweds.

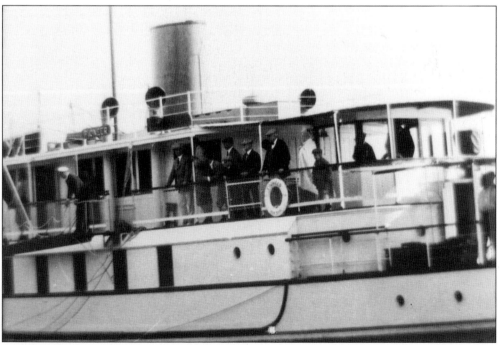

President Warren G. Harding and his yachting party dock the presidential yacht, *Pioneer*, at the Hotel Indian River dock in Rockledge in 1921. Harding visited Rockledge the previous year as president-elect. Mrs. Harding's (nee Florence Kling) brother, Clifford B. Kling, had a winter home on Rockledge Drive.

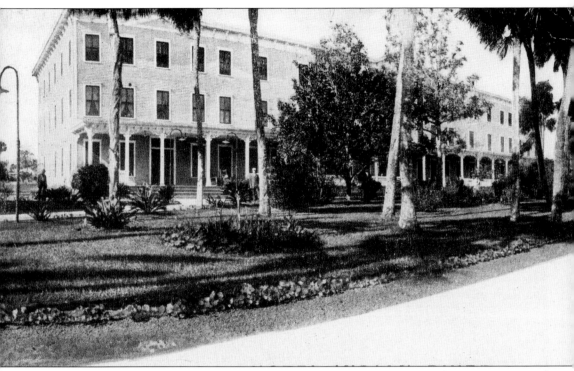

The Hotel Indian River went through several incarnations at the same site between Barton and Orange Avenues. This is the third edifice to bear the name. The first hotel burned, the second was demolished around 1900, and the third survived into the 1920s. The advertising for the

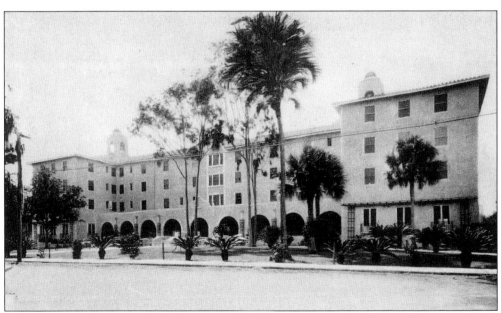

The New Indian River Hotel opened on January 24, 1924. The hotel was built on the site of the former Hotel Indian River. This building survived until it was razed in the 1970s to make way for the construction of the Indian River condominiums.

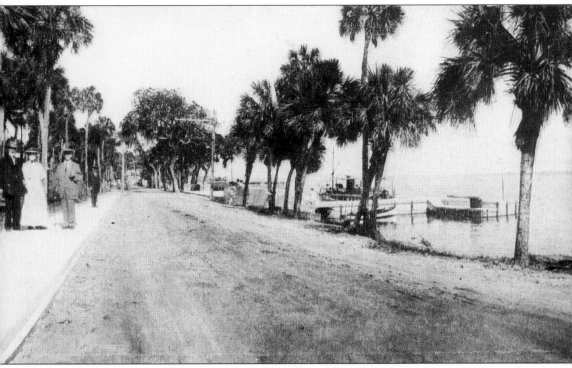

hotel claimed it was "one of the finest, most liberally conducted winter resorts in the South." The hotel could accommodate 300 guests, boasted a fine orchestra, and included an on-site telegraph office.

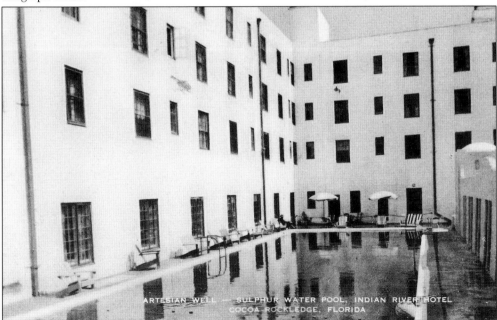

Artesian wells provided water for the swimming pool at the New Hotel Indian River. Gertrude Ederle, the conqueror of the English Channel, used this Olympic-sized pool for some of her training.

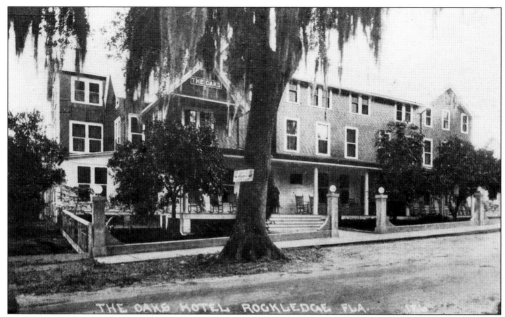

The Oaks Cottage, later called the Oaks Hotel, was on Barton Avenue in Rockledge. The complex offered winter visitors cottage accommodations. Part of the Oaks Hotel still stands, although a 1969 fire destroyed several of the adjacent buildings. The old Rockledge City Hall and jail are located nearby.

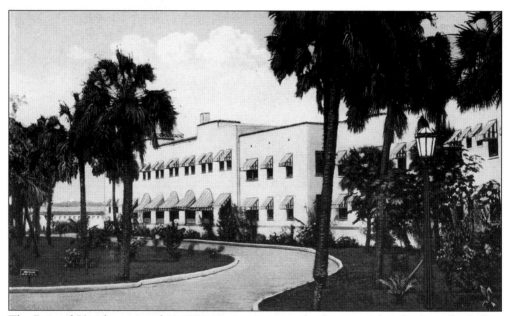

The Brevard Hotel re-opened in 1934 as a successor to the fine resort hotels along the Indian River. Under the direct supervision of the Laycock family, who owned it, the Brevard was located on Oleander Point. Built of poured concrete, the Mediterranean-style hotel was a temporary home to many important visitors, including Vice President Hubert H. Humphrey. Its 60 rooms provided guests with a delightful view of the Indian River.

Two
PEOPLE

The people of central Brevard County, more so than the topography and climate, give the region its distinctiveness. Early settlers came from a variety of places and for a variety of reasons. In the main, these settlers were white, Anglo-Saxon, and southern, although a few African-Americans also established themselves in the region. The original settlers were few in number, and, as the following photographs depict, were individuals with strong personalities and substantial backbones.

Within a short time after the end of the Civil War, however, the pleasant climate, abundance of wildlife, the opportunities for success, and, some would say, the splendid isolation of the area attracted a growing number of settlers. Steamboats, railroads, and automobiles gradually allowed settlers to reach the furthermost spots along the Indian River. As the decades passed, more and more people came to the region. These pictures provide an overall view of their lives and the culture they created.

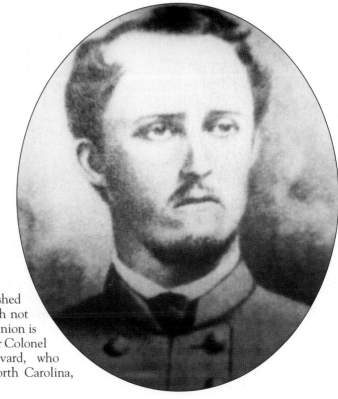

Brevard County was established on March 14, 1844. Although not a certainty, the prevailing opinion is that the county was named for Colonel Theodore Washington Brevard, who migrated to Florida from North Carolina, and is pictured here.

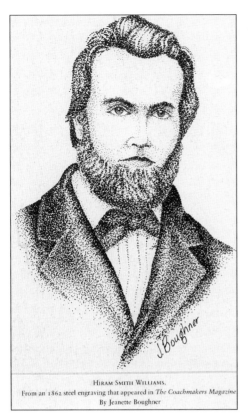

Hiram Smith Williams, who first came to Brevard County in 1872, was an early pioneer in Rockledge. A native of New Jersey, Williams served in the 40th Alabama Infantry Regiment during the Civil War. After settling in Rockledge, he operated a citrus grove, served two terms as a state senator, and was president of the first telephone company in Brevard County.

HIRAM SMITH WILLIAMS.
From an 1862 steel engraving that appeared in *The Coachmakers Magazine*
By Jeanette Boughner

Eliza Ann Field, John Robert Field (her husband), and Samuel J. Field (her brother-in-law) were the first settlers in the small Merritt Island town of Indianola. The homestead they established in 1868 is still owned by the Field family.

Samuel J. Field operated a general store on the banks of the Indian River. For many years, he served as the postmaster of Indianola, since the post office was located in his store.

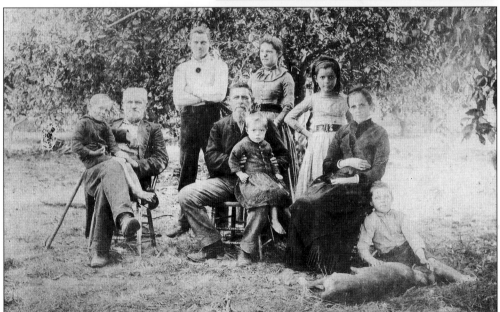

The Field family of Indianola pose for this family portrait in the orange grove that was adjacent to the Field home. Pictured here are, from left to right, as follows: (sitting) Samuel Barton, John Moss, Samuel Joseph Field, John Robert Field, Julia Field, and Charles Emmit Field; (standing) Jacob Moss, Martha Field, and Ethel Field.

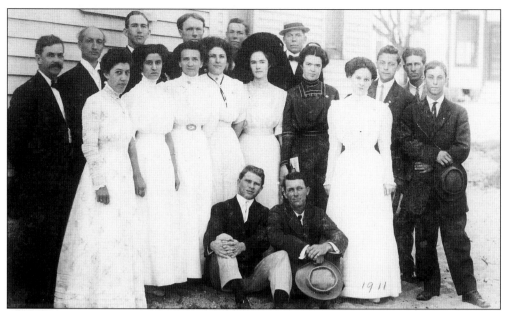

This 1911 picture shows the members of the Sunday school class of the First Methodist Church in Cocoa. From left to right, they are as follows: (front row, sitting) A. Roy Trafford and Parson Patterson; (front row, standing) Miss Hoover, Miss Davis, Miss Puckett, Mrs. Puckett, Miss Pearl Hendry, Miss Ellen Wells, Mrs. M.L. Neal, Arthur Scholtz, Lewis Beares, and Tommy Blyth; (back row) E.C. Johnson, R.O. Wright (minister), G.E. Hendry, M.L. Neal (school principal), Amos Wooten, and August Lemmert.

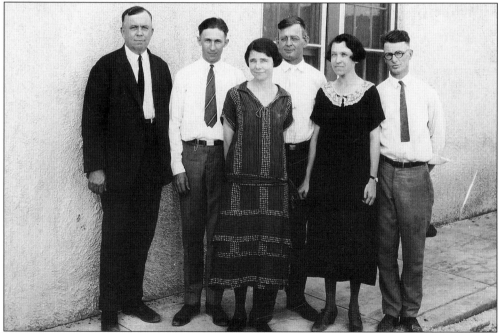

These men and women made up the staff of the Cocoa Post Office in the 1920s. They are, from left to right, O.K. Key, Horace Thomas, Eva Powell (Ford), Bob Godbey, Mae Pierson, and A.E. Booth.

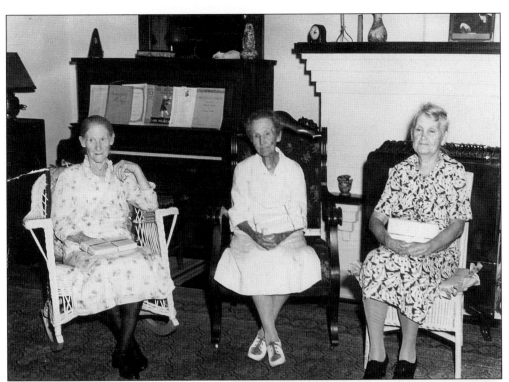

The Indian River area was often touted as a marvelous area for sick people to recuperate from severe illness. Here, three ladies remember the "good old days" in central Brevard. Mrs. Dell Munson (left) of Georgiana first came to the area at age 16 with a disease that gave her only a few shorts months to live. "Aunt Barbara" Faber (center) lived to be 104 years of age. Mrs. Honeywell (right) was the wife of the Cape Canaveral lighthouse keeper.

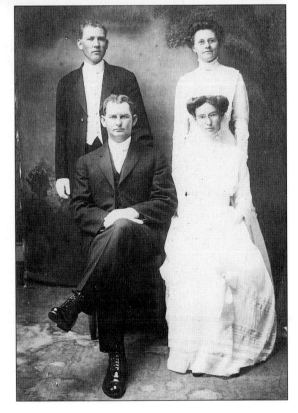

Joseph Edward Field of Indianola married Louise Cannatta of Merritt Island in a formal ceremony on September 26, 1911. Lawrence Bulgin served as best man, while Irene Field Miot was the matron of honor. The couple resided at the Field homestead in Indianola.

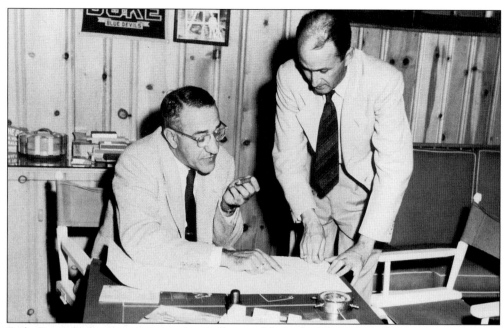

Early Cocoa had a reputation as a baseball town. Not only did the town have a semi-pro team, it was at one time the home of a major league umpire school. Even today, baseball plays an important role in the local economy. Central Brevard County is the spring training home of the Florida Marlins and is also the home for the Marlins's minor league franchise. Here, J.V. D'Albora and Harry "Peewee" Murdock discuss activities of the Cocoa-Rockledge baseball teams.

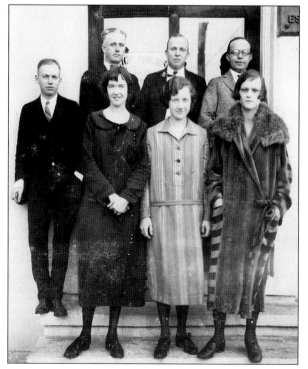

Cocoa was a dynamic player in the Florida boom of the 1920s. Banking was an essential component of the development of the area, and Cocoa had several banks. The staff of the Cocoa State Bank, from left to right, are as follows: (front row) Naomi O'Rourke, Naomi Lindsay Buckalew, and Ruth Gordy Savage; (back row) ? Rankin, Ed Porter, unidentified, and Albert G. McGlaun.

Each year, citrus growers and packing houses in the area produced a community festival called the Orange Jubilee. A carnival was brought to town, a massive parade was held in Cocoa, and a king and queen were crowned. Betty Curwen and Mayo Hill are captured in their royal regalia in this 1939 photograph.

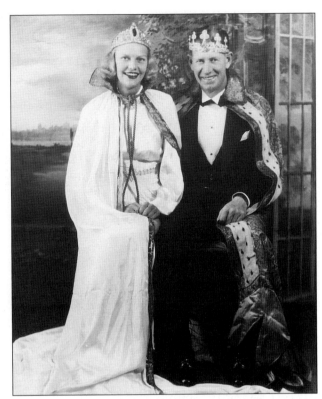

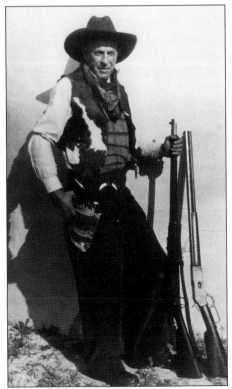

George Morris, the bridge tender on the Cocoa-Merritt Island bridge, was a self-proclaimed expert marksman. Morris dressed the part of a Florida cow hunter. Here he is portrayed with his six shooter, a bolt action hunting rifle, and his lever action Winchester.

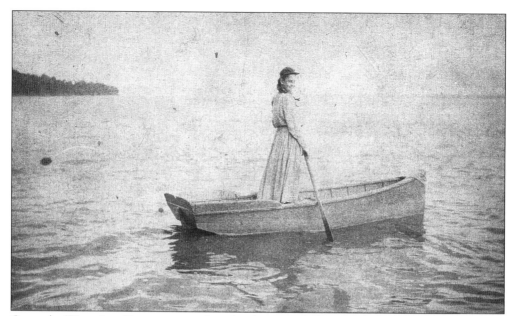

Gertrude Wyoming Breese personifies the beauty of the Indian River in this c. 1900 photograph. Just about everyone living on or near the Indian River had a boat of some kind, and residents frequently rowed down the shore to visit neighbors, attend social events, or to purchase goods in town.

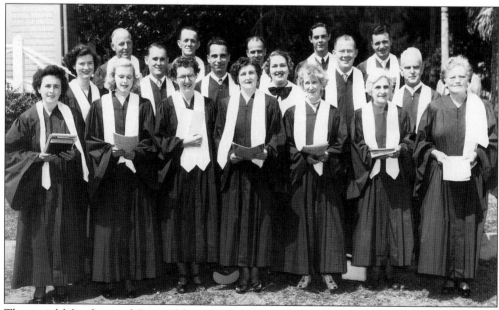

The social life of central Brevard has always centered around churches. Here, the Rockledge Presbyterian Church choir poses with their choral robes in a 1950s photograph. They are, from left to right, as follows: (front row) Ann Stewart, Carolyn Parrish, unknown, Mrs. J.D. Shepard Sr., Jane Greer, Alta Wakefield, and Miriam Childs; (middle row) unknown, Roger Dykes, unknown, Lois Dixon Gray, Billy Martin, and unknown; (back row) Carl Wolary, George Harvey, Ozzie Stewart, Howard Gould, and Hugh Parrish.

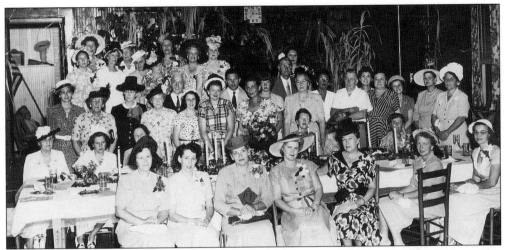

Members of the Indian River Music Club enjoy a luncheon in 1949. They are, from left to right, as follows: (front row) Pearl Trafford, Irma Norwood, Billie Revels, Lilac Liken, Laura Buckles, Edith Thomas, and Marge Walley; (second row) Mrs. Kipp, Mrs. Strickland, Ethel Loring, unknown, Alveretta Broderson, and unknown; (third row) Helen Bennett, Mrs. Bennett Sr., Mrs. Hopkinson, Jane Greer, unknown man, Vi Williams, Virginia Hendry, Bob Roth, Mrs. Patton, Jean Patton, Laura Dunham, unknown, unknown man, Lydia Roth, Mrs. Johnson, Mrs. Green, unknown, and Mrs. Malpas; (fourth row) Doris Dyal, Vollie Maxwell, Alta Wakefield, Mrs. Page, Marion Childs, and Mrs. Maxwell; (back row) Edith Voss, unknown, Jane Lewis, Marilu Shepard, and Louise Gibbons.

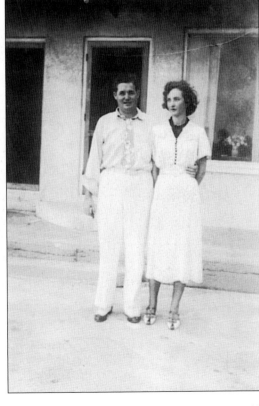

"Local Boy Makes Good!" could be the title of this picture. Vasser Carlton, shown here with his sister, Coralie Carlton Crockett, served as the chief justice of the Supreme Court of Florida.

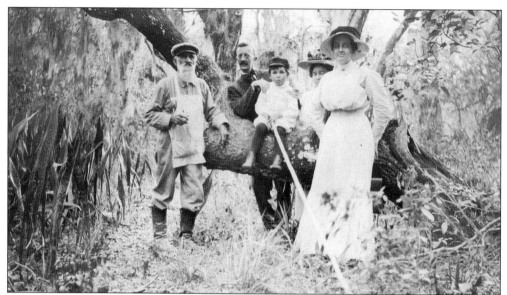

There were many visitors to Dr. William Wittfeld's Fairy Land grove on Merritt Island in the early 1900s. Pictured here are, from left to right, Dr. Wittfeld, Mr. Fiske, Breese Provost, Myra Williams, and Gertrude Breese Provost. Fairy Land Hill is the highest point on Merritt Island.

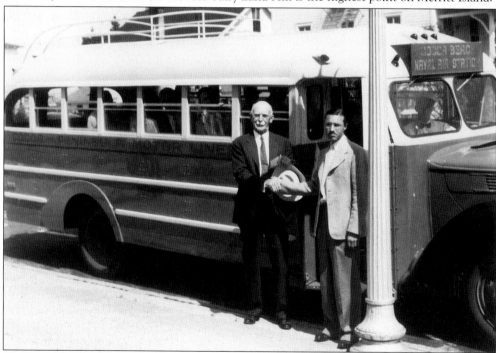

The development of Cocoa Beach and the construction of the Banana River Naval Air Station brought people to the barrier islands. With the increase in population, it was necessary to find reliable means of transportation between the Indian River communities and the beach communities. One of the ways was through the creation and operation of a bus line. Here Cocoa Beach mayor Frank G. Pulsipher and Cocoa mayor W.G. Akridge shake hands to commemorate the linkage of their two cities by the Peninsular Motor Line.

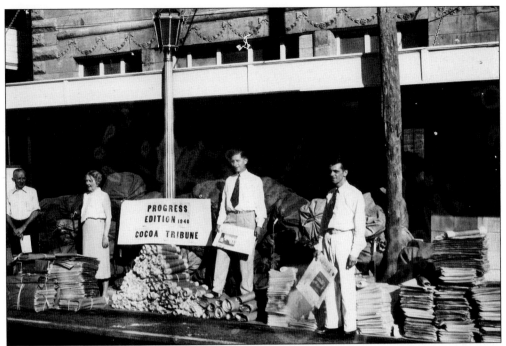

It was a big day for the Cocoa *Tribune* when the *Progress Edition* hit the stands on November 14, 1940. This edition contained 66 pages of Cocoa history, complete with photographs. Mrs. Marie Holderman, shown in this photograph, was the founder of the paper. The Cocoa *Tribune* was a weekly, and the subscriber price was $2 per year. The man on the right of the sign is John Pound. The men on the extreme left and right are unidentified.

William Cesary stands next to his Stearman spray plane at the Merritt Island Airport. He was one of the first mosquito control pilots in the area. The residents of Brevard County were delighted that a chemical compound known as DDT proved to be an effective control. Of course, residents had no idea of the serious long-term environmental damage this chemical could cause; they were simply delighted to be rid of the pesky nuisances that had tormented them for so long.

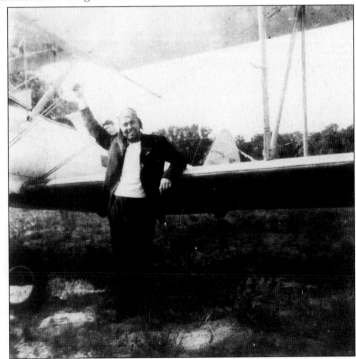

Gus Edwards, lawyer, civic leader, and entrepreneur, was known as the "Father of Cocoa Beach." Alone and in association with other businessmen, Edwards developed four subdivisions in Rockledge, three on Merritt Island, and seven on Cocoa Beach by 1953. He is saddled with the stigma of being the individual who introduced the armadillo into Florida. The exotic animals were kept in a private zoo he operated as a tourist attraction to lure prospective buyers to his land development projects, and when the boom became a bust, he was forced to release the armadillos, as he could no longer afford to feed them. Edwards was also an important figure in getting the space program located in Brevard County.

James F. Mitchell, a native of Scotland, arrived in central Brevard County in July 1884. He homesteaded on Merritt Island. Mitchell served as the second clerk of the court of Brevard County.

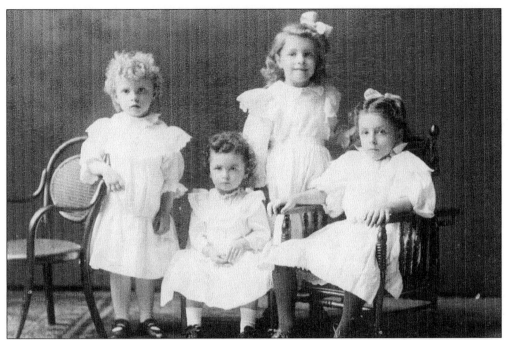

The children of James and Lena Norwood Mitchell posed for this formal portrait in the late 1890s. From left to right are Lenita, known as "Nita," Catherine (Brown), Mary (Ellington), and Margaret (Brady-Abney).

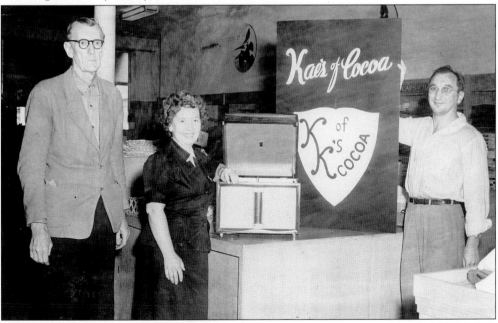

Mrs. Lowell Fair receives the first prize for her suggestion for a name to replace that of Crispin's Department Store. Her winning suggestion was "Kae's of Cocoa." Even earlier, the store had been named Walter's Department Store. G.F. Weldon, the appliance dealer, is on the left. Jerry Krnoul, the owner of the store, is on the right. The prize was a hi-fidelity record player and a phonorama.

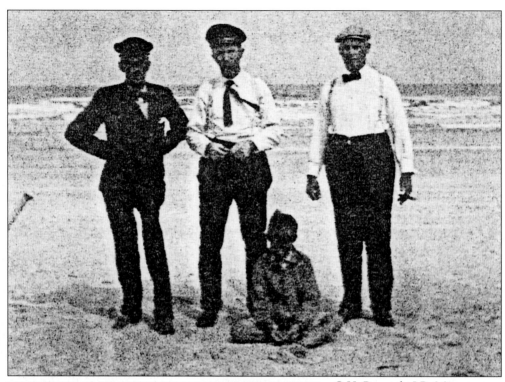

C.H. Peacock, J.R. Miot, George Wallace, and young Charlie Reed enjoy a day at the beach in 1905. John R. Miot was a county commissioner from the second district.

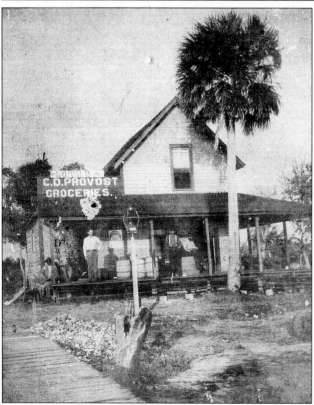

This picture, dated April 30, 1895, shows the C.D. Provost grocery store at Lotus and the relative isolation of this rural store.

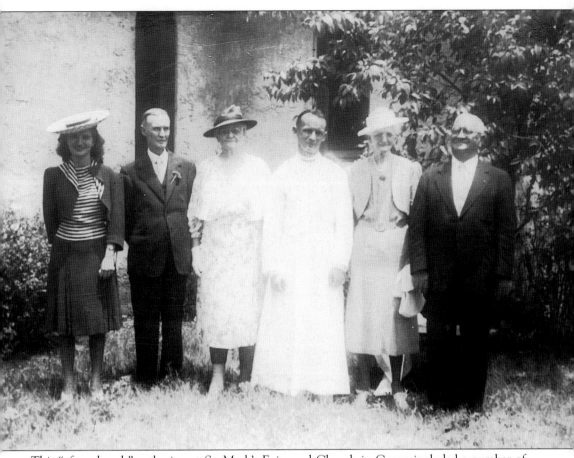

This "after church" gathering at St. Mark's Episcopal Church in Cocoa included a number of prominent Cocoa residents. They are, from left to right, Betty Ann Jameson Armistead, Cocoa mayor Fred Hull MacFarland, Mrs. Otto Grosse, Father William Hargrave (later bishop of southwest Florida), Mrs. MacFarland, and Otto Grosse.

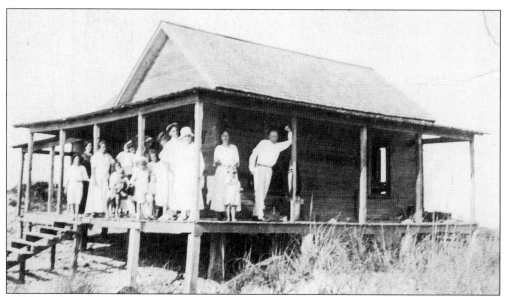

Oceanus, the small community adjacent to the north boundary of today's Patrick Air Force Base, was the area that early settlers visited on day trips and picnics. It was possible to cross the Banana River from Georgiana and avoid Horti Point. Oceanus was a short walk across the barrier island. Some families erected beach houses for longer stays on the Atlantic coast.

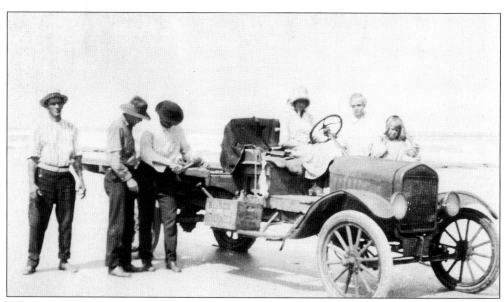

Where man goes, technology follows. This Ford truck was taken by barge to Oceanus. The use of a truck on the hard beach sand meant that visitors could see more of the barrier island and spend more time beach combing and hunting for sea turtles.

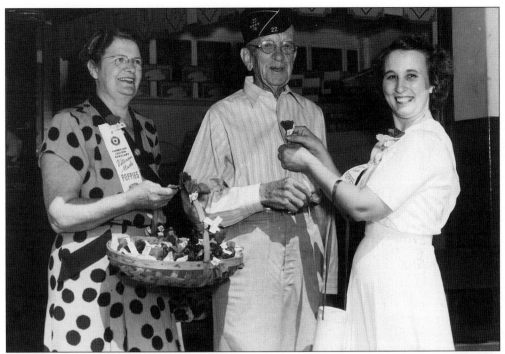

Nan Blair, C.A. Fiske, and Leota Shackelford celebrate Memorial Day 1949 by selling poppies for the American Legion Post 22. Blair and Shackelford were members of the Legion Auxiliary.

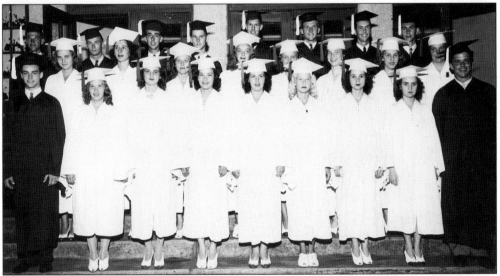

The graduating class of Cocoa High School in 1943 smiles proudly for the camera. Each year, graduates hold their individual class reunions on the second weekend of March as part of the Annual Mosquito Beaters reunion. Pictured here are, from left to right, as follows: (front row) Jack Baker, Betty Lu Yates, Marilu Shepard, Carol Johnson, Lennie Davis, Marion Drake, Betty Caster, unknown, and James Brady; (middle row) Janell Harsha, Teresa Heilman, Beth Atkinson, Joann Hobbins, June Grey, unknown, Lucille Deese, and Frances Carter; (back row) Oliver Bossom, Owen LaRoche, Jack Smith, Ralph Ramsey, Alvah Broderson, Bill Poole, Frank Wooten, and Edgar Pritchett.

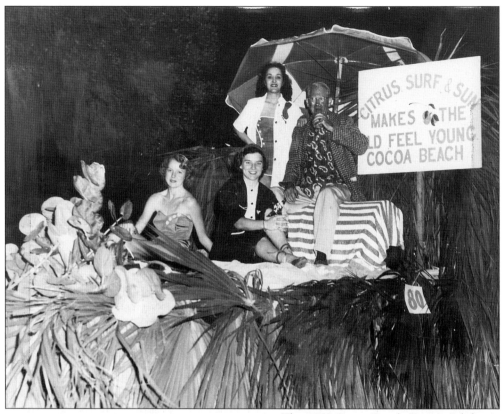

The 1953 Cocoa Beach Orange Jubilee float proclaimed, "Citrus, Surf and Sun make the old feel young." Shown here are, from left to right, Wynell Faircloth, Clancy Tinker, Marlene Minella Wells, and Horace Cook.

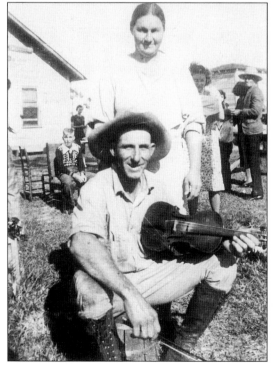

This 1930s picture of Elijah and Annie Cox depicts a family gathering. Elijah Cox had a reputation for being an excellent hunter, trapper, and cattleman. He worked with the State of Florida Fever Tick Eradication Program. We cannot make a judgment on his abilities as a fiddler.

Three
MERRITT ISLAND AND COCOA BEACH

The central Brevard County area was closely tied together by a network of families and businesses. From Cocoa Beach to Rockledge and south to now-ghost towns like Bonaventure and Georgiana, the cohesiveness of central Brevard County promoted a small town atmosphere of concern for individuals and an interest in their welfare. Today, that sense of belonging is slowly giving way to the inexorable pressures of population growth and development. Nevertheless, the desire for this once vital part of the central Brevard County experience is kept alive through the efforts of a small band of natives and "long timers" who meet annually on the second weekend of March for the Mosquito Beaters Reunion.

Formed in 1986 as an excuse to bring together central Brevardians with a shared past, the two to three thousand Mosquito Beaters pour over old pictures, recall common experiences, and fondly remember how things used to be. A more gregarious group never existed anywhere, and if the Mosquito Beaters are successful in their educational efforts, this same feeling of community and belonging will be passed on to their offspring.

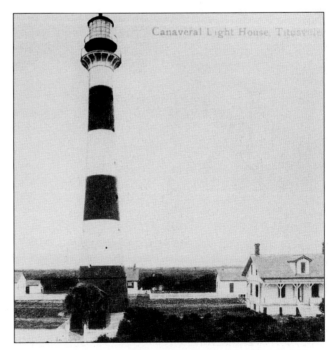

The first Canaveral Lighthouse was built in 1848. The second lighthouse was completed following the Civil War in 1868. In the 1890s, beach erosion required that the lighthouse be torn down and moved to its present location about a mile further inland. In 1939, the Coast Guard took over the operation of the lighthouse. Today, the structure is closed to the public since it is located near the launch gantries of the Kennedy Space Center. Just as the lighthouse guided seafarers in the past, it now serves to welcome home voyagers from space.

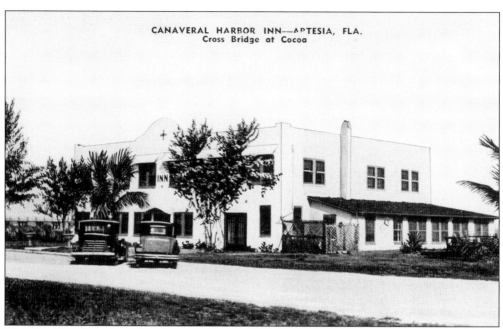

The Canaveral Harbor Inn was a popular get-away for central Brevardians. Located on the beach, the Canaveral Harbor Inn's management offered weekend specials for two which included an "outside" room and all meals. The price? A mere $5! After the death of Harry Houdini, the magician, Mrs. Houdini sought refuge here to escape the myriad telephone callers purporting to be her husband calling from the great beyond.

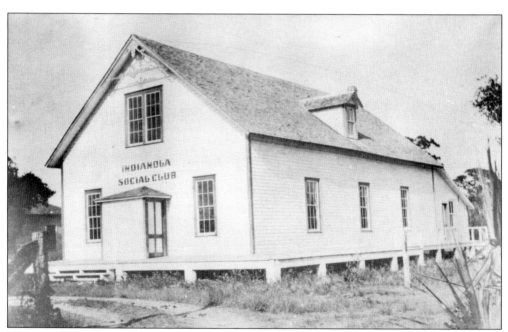

This wooden building was the Indianola Social Club. Residents of the small village on Merritt Island would gather at this structure for various community events, weddings, dances, and other group activities.

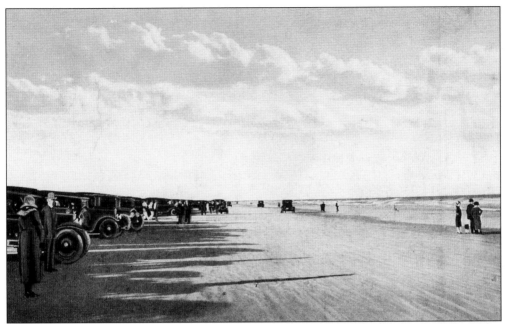

As late as the 1920s, Cocoa Beach was a favorite place for visitors to come and drive their automobiles. The wide beach and hard sand provided a great stage for young men and women to see and be seen. Unfortunately, construction of breakers to protect the entrance to Port Canaveral has resulted in a great deal of beach erosion, and the beach is now a narrow strip of sand.

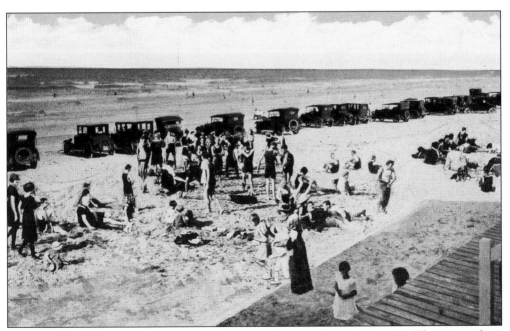

Cocoa Beach attracted large numbers of local residents and winter visitors. This scene, from around 1910, shows the broad expanse of beach at mid-tide and the varied uses beach-goers put it to.

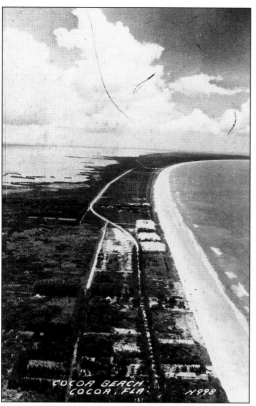

This aerial view of Cocoa Beach in 1948 provides a terrific view of the barrier island and its beaches. Few houses occupied the coastline at this time, but this would change dramatically with the growth of the space center and the dredging of Port Canaveral (upper right). Today, houses are jammed together in subdivisions and a variety of restaurants, night clubs, and T-shirt shops line Highway A1A, just a few hundred feet from the shore.

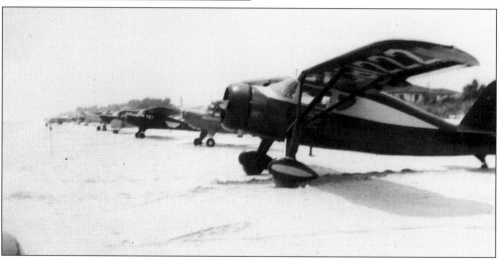

Seventy-eight airplanes and more than 150 pilots and passengers lined Cocoa Beach in May 1951 when the Cocoa Beach Chamber of Commerce held its first "Breakfast Fly-in." The pilots were entertained at the Patrick Air Force Base Open House. The airborne visitors were taken to view the progress made at the Canaveral Harbor project. More than 1,500 people turned out to view the spectacle of the planes landing and taking off. William "Bill" Piper, the president of the Piper Cub Manufacturing Company of Lock Haven, Pennsylvania, was one of the flyers who attended. Flyers came from more than 22 locations in Florida, including the "Flying 99," an all-female flying club from Orlando.

Two brothers from Macon, Georgia, Samuel J. and John R. Field, along with John's wife, Eliza, were the first permanent settlers on Merritt Island. They named their settlement Indianola. The Field family homestead is on the National Register of Historic Places.

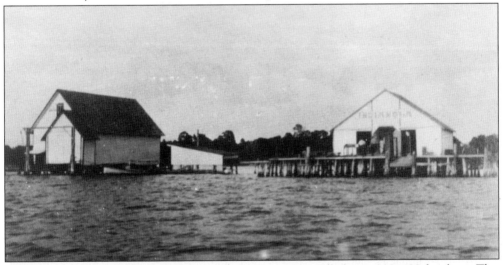

The Indianola dock or the Mill Dock, as it was sometimes called, was 300–400 feet long. This great length was necessary to reach water deep enough to accommodate the trade boats, mail boats, and steamers that conveyed goods and passengers to Merritt Island. Indian River docks (the longest of which was 1,500 feet) of any great length also featured small railroads, usually one or two feet wide, for transporting heavy freight loads. This system was critically important in the transportation of packed citrus crates or barrels from packing houses to the end of the wharves.

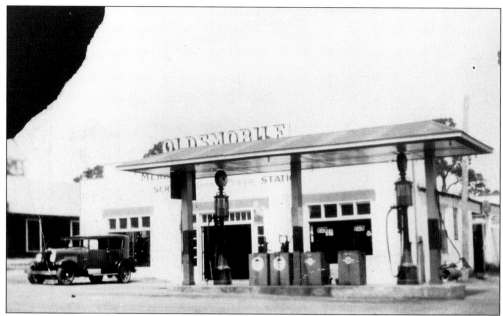

Headley's Oldsmobile dealership and service station, located at the corner of Highway 520 and Tropical Trail, was a favorite hangout for sports-minded Merritt Islanders. Owners Bill and Ira Headley were great fans of baseball, and when the World Series broadcasts were tuned in on the radio in the garage of the dealership, locals from all over the area would fill the building. Of course, heavy static frequently disrupted the descriptions of critical plays, but the crowd stayed until the final out of each game. Bill Headley also enjoyed a reputation as a fine player in some of the local leagues.

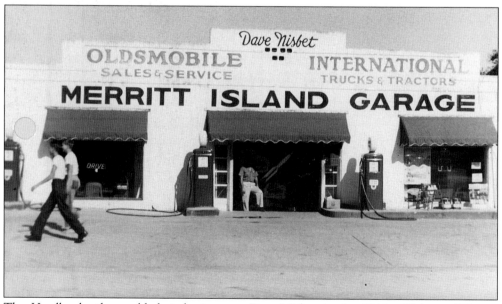

The Headley brothers sold their business to Dave Nisbet in the 1940s. Highway 520 was widened soon afterwards, and the front part of the building became part of the highway right-of-way. Nisbet also became the dealer for International trucks and tractors at this location.

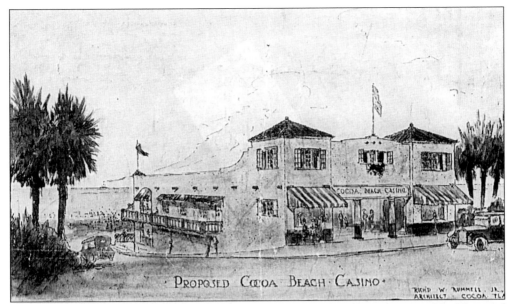

Rockledge architect Richard W. Rummell Jr., who designed the Cocoa Municipal Building and the Valencia Road subdivision in Rockledge, was also the architect for the proposed Cocoa Beach Casino. During the mid-1920s, Gus Edwards and others sought to make Cocoa Beach the preferred Florida beach destination for tourists.

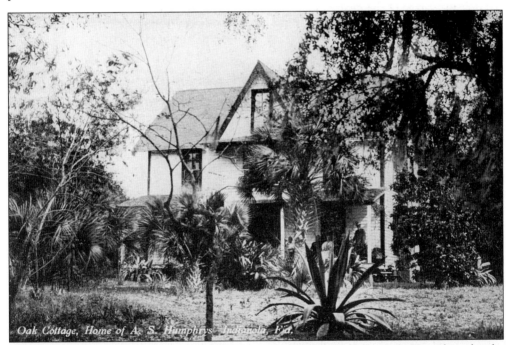

This house was known as Oak Cottage and was the residence of the A.S. Humphrys family. Located in the small Merritt Island community of Indianola, Oak Cottage was typical of the second homes built by early settlers. Usually, the original home was little more than a palmetto hut or a slab-sided shack, but as homesteads were established and prospered, living quarters became more substantial.

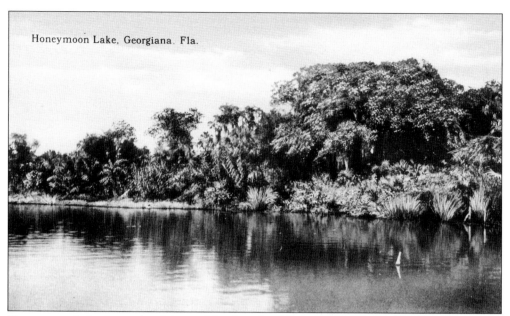

Honeymoon Lake, Georgiana, Fla.

Honeymoon Lake, located on Merritt Island south of Georgiana, is a salt water lake. The lake is part of the Indian River lagoon and also part of Fairy Land, the estate of Dr. William Wittfeld, a renown botanist. Capt. Douglas Dummett, a locally prominent citrus grower, often came to Honeymoon Lake to consult with Dr. Wittfeld. Mr. Dummett is buried on the Fairy Land property. The lake is now surrounded by fine homes.

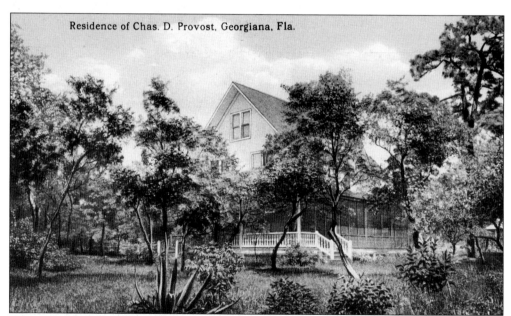

Residence of Chas. D. Provost, Georgiana, Fla.

This beautiful house was the residence of the Charles D. Provost family. The Provosts, longtime residents, were well-known merchants, operating a grocery store and then an office supply company.

Four
CHURCHES AND HOSPITALS

Early settlers in central Brevard County brought with them a strong sense of community and the need for community organizations. Religion played an important role in the lives of early settlers, just as it does for today's residents. As the various religious denominations prospered in the area, church buildings were erected. Ranging from simple one-room country churches to more elaborate city edifices, the institutions provided another thread of continuity and comfort for area families.

From these centers of moral instruction sprang the recognition that individuals and organizations were merely units in a larger extended family grouping. As such, there was a need for everyone to work together to create new facilities to care for the physical, intellectual, and spiritual needs of the larger community. Out of this early and profound sense of civic responsibility came a willingness to join forces to build viable institutions. The pattern of cooperation established in former decades continues today in central Brevard County.

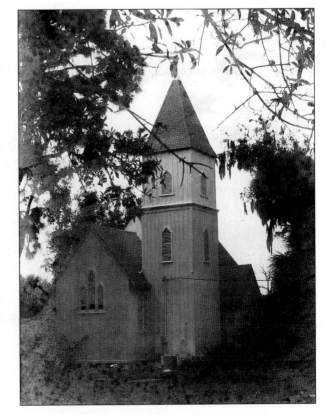

The community of Courtenay on Merritt Island is said to have been named for the mayor of Charleston, South Carolina. St. Luke's Episcopal Church was built in 1880 by pioneer families who migrated to Merritt Island from the city of Charleston and John's Island. Among the families who founded the church were the LaRoches, the Porchers, and the Sams.

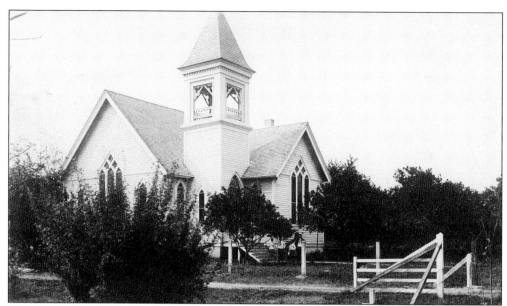

The acknowledged founder of the Rockledge Presbyterian Church was Cornelia Brown Smith Magruder, the wife of "Major" Cephas Bailey Magruder. Mrs. Magruder was the daughter of a Presbyterian minister, teacher, and published author. This picture shows the third church building, which housed the congregation from 1908 until the present building was built across the street in the 1950s. The Rockledge Presbyterian Church was organized as a congregation in 1877 and received its charter in 1884. Other charter members were Mrs. E.A. Smith, J.K. DeKay, W.S. Smith, and Albert S. Magruder.

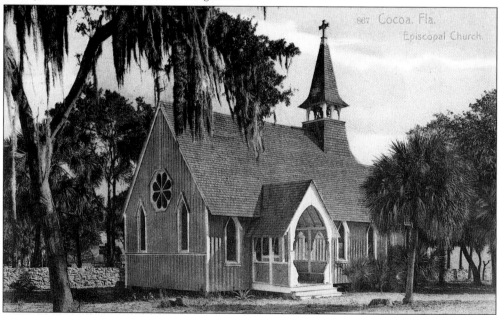

This picture of St. Mark's Episcopal Church in Cocoa shows the church in its original setting. Built in the mid-1880s on Church Street, the complex also includes Thursby Hall (named for a famous opera singer of the era) on the west side of the sanctuary. The two buildings were eventually connected and extensive renovations were made in the 1990s.

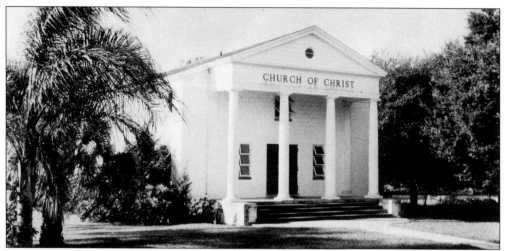

The Cocoa Church of Christ was located on Poinsett Drive. The congregation moved from this location in the early 1960s and the building was vacant. The Community Women's Club of Cocoa purchased the vacant building in 1966 for use as a clubhouse. The purchase was made possible by a generous gift from the estate of Gertrude H. Alford, the widow of a wealthy automobile executive.

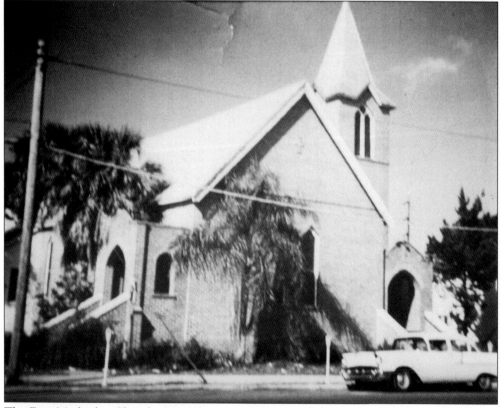

The First Methodist Church congregation, at 505 Brevard Avenue in Cocoa, was founded in 1883, and the first church building was erected in 1889. In 1959, the congregation vacated this building and moved into new facilities.

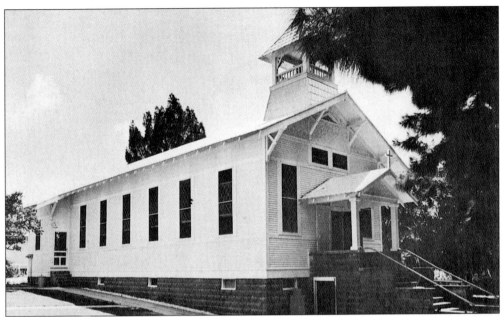

The St. Mary's Church congregation in Rockledge first assembled at the home of Mr. and Mrs. Gabriel Gingras in 1881. The church was served by Father O'Boyle, who traveled the East Coast on horseback and celebrated Mass in private homes. This building still stands on Barton Avenue, across from the present St. Mary's church, school, and convent.

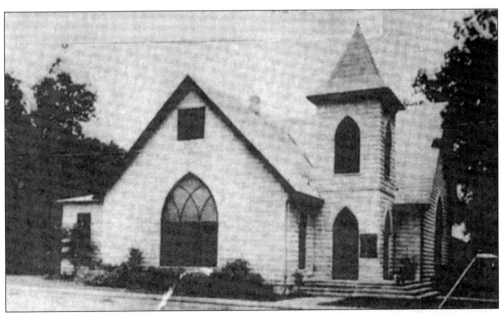

The First Baptist Church of Cocoa was organized in 1911. The original church building stood at the corner of Brevard Avenue and Oak Street, the site of the present church complex. Charter members were Mr. and Mrs. J.N. Chalker, George Coombs, N.J. Cooper, Mr. and Mrs. A.T. Dixon, Mr. and Mrs. J.R. Garren, Mr. and Mrs. J.T. Hodges, Mr. and Mrs. C.B. Owens, Alida Platt, Ruby Platt, and Mrs. Adela Rembert.

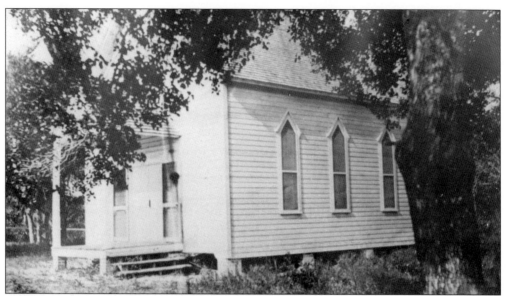

The Indianola Baptist Church building on Merritt Island also served as a schoolhouse until 1925, when the building was purchased by a private individual.

The Zion Orthodox Primitive Baptist Church was located on Avocado Street in Cocoa. The congregation moved to the corner of Fiske Boulevard and Poinsett Drive in 1976. This African-American congregation is one of the oldest congregations in central Brevard County and dates from the mid-1880s.

This is Wuesthoff Hospital in the early 1950s. Eugene Wuesthoff, a winter resident of Cocoa Beach, contributed money and his name to the establishment of a hospital facility in 1941. The ten-bed hospital served the entire central Brevard region. This facility was considered to be an absolute godsend, since patients needing to be hospitalized before it was constructed had to go to Orlando or Jacksonville.

In the early 1970s, Wuesthoff Hospital added a new 300,000-square-foot facility to its physical plant. The new facility, which fronted on Longwood Avenue in Rockledge, offered the latest in medical technology. Wuesthoff Hospital has continued its growth and today is considered one of the area's premier medical facilities. In addition to its main facility, the hospital maintains a large network of satellite clinics and offices.

Five

RECREATION AND SPORTS

In the days before radio and television, residents of and visitors to the Indian River region entertained themselves through a number of different activities. Blessed with an overabundance of wildlife and fish, the Indian River was viewed as a sportsman's paradise. Each year, thousands of hunters took to the woods in pursuit of ducks, bears, alligators, and hundreds of other species of game, while an equally large group of fishermen tried their luck on the waters of the Indian River or the Atlantic Ocean.

Central Brevardians also took great delight in other sports activities. At one time, Cocoa fielded a semi-pro baseball team made up of local residents and a few imported "ringers." City athletic leagues, the American Legion, Little League, the Pop Warner League, and a number of church leagues promoted this fascination with baseball throughout the summer. The Cocoa-Rockledge-Merritt Island area produced a number of athletes who went on to collegiate or professional careers. In addition, high schools provided football and basketball programs that gave an added dimension to the local sports scene. Today, central Brevard County is the home of the Florida Marlins's spring training camp and the home of the Manatees, the minor league franchise for the Marlins.

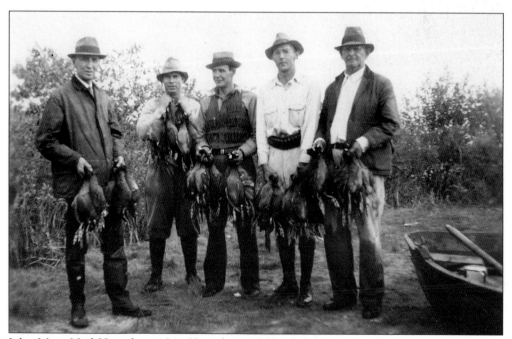

John Miot, Neil Humphreys, Lee Humphreys, Edward Field, and Joe Field display their prizes after a day's shooting on Merritt Island.

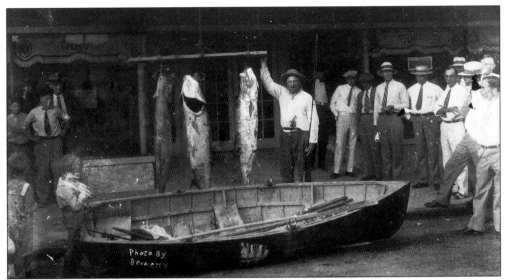

A big catch draws a crowd to ooh and aah! Dr. C.L. Hill shows off his catch to envious local businessmen in front of the Travis Hardware Store on Delannoy Avenue.

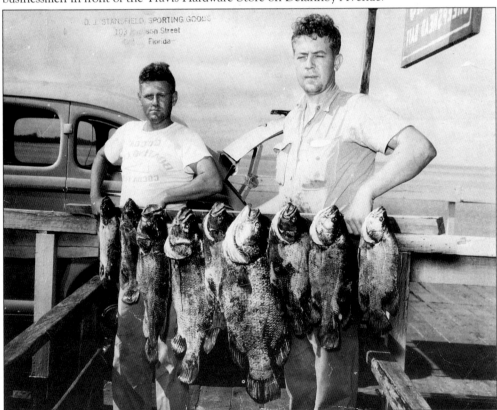

Don Stansfield and Gary Bennett with a catch of tripletails in October 1948. The writing on Don's T-shirt is reversed because the photographer printed the picture backwards. This picture was taken outside Bennett's Bait and Tackle Shop at the end of the old relief bridge on Highway 520.

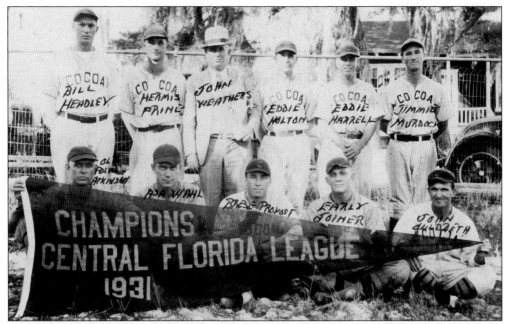

The Cocoa baseball team was the Central Florida League champion in 1931. Pictured, from left to right, are as follows: (front row) "Old Folks" Atkinson, Asa Wahl, Breese Provost, Early Joiner, and John Culbreth; (back row) Bill Headley, Hermus Prine, John Weathers, Eddie Holton, Eddie Harrell, and Jimmie Murdock.

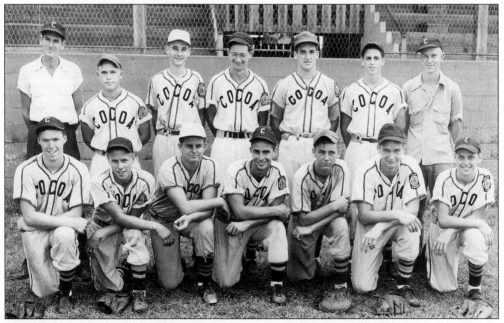

The 1951 Junior American Legion baseball team featured a number of local youths. From left to right, they are as follows: (front row) Maurice Campbell, Dale Bryant, Dean Mink, Joey Prine, John Barnes, Bob Pereira, and Bob Anderson; (back row) Mitchell Tidwell (coach), Turk Adkins, Bob Brewster, Dave Pereira, Jay Gould, Arthur Mackey, and Russell Roesch (manager).

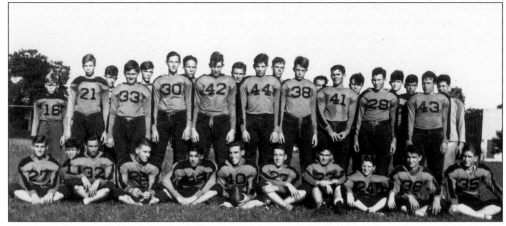

The 1941 Cocoa High School football team was a team that included one of the authors of this book as a member. Pictured are, from left to right, as follows: (front row) Amos Cox, Charles Pooley, unknown , Ralph Ramsey, Lee Hipp, Bunt Travis (holding football), Eugene Spell, Lloyd Register, Bruce Walker, Richard Rembert, and Don Stradley; (back row) Dick Griggs, Jack Baker, unknown, Lowell Gray, Bud Pelham, O.B. Matthews, A.L. "Buddy" McGlaun, Elton Dixon, Bill Poole, Clinton Schonemann, Bill Summerall, Charles "Chuck" Reed, George "Speedy" Harrell, Jack Nicholson, Abe Thomas, Edgar Pritchett, Howard Brannen, unknown, Leo "Sharkey" Nelson, and unknown.

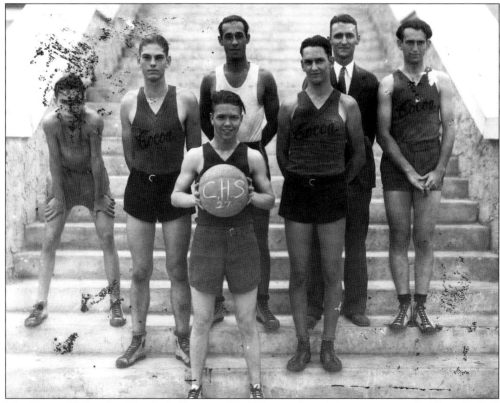

The Cocoa High School basketball team of 1927 is seen here. The young man holding the ball is Winston Osteen.

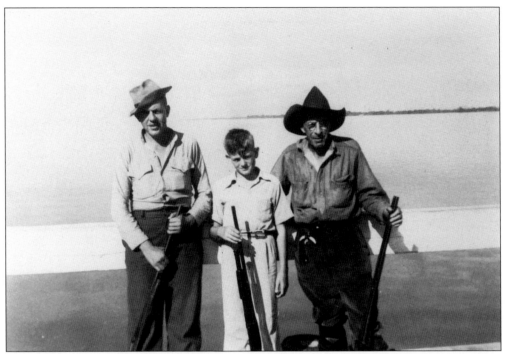

Gary Bennett, Emory Bennett, and George Morris get ready for a hunting trip. Emory Bennett was awarded the Congressional Medal of Honor posthumously for his bravery during the police action in Korea. Today's Bennett Causeway is named in his honor. Gary Bennett served as a mayor of Cocoa.

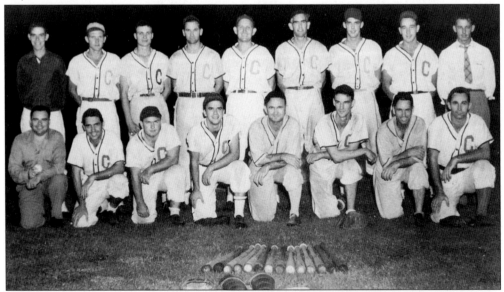

The Cocoa Indians played baseball at Provost Park in 1948. Those pictured here, from left to right, are as follows: (front row) C.D. Kidd, Sonny Butt, Lloyd Register, Gus Hipp, Johnny Culbreth, Richard Rembert, Eddie Harrell, and Jim Caldwell; (back row) "Bunt" Travis Fennel, Billy Poole, Jack Parrish, Newt Jones, Donald "Moe" Stradley, Grady MacAllister, Lee Hipp, Eugene Spell, and J.L. Smith.

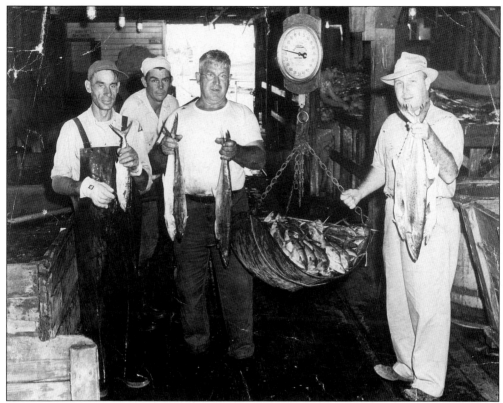

Eddie Fischer, pictured on the right, weighs fish caught at the end of the old pier at Canaveral. Eddie was one of the Fischer brothers of Cocoa Beach who were associated with Fischer Seafoods and the Surf Restaurant.

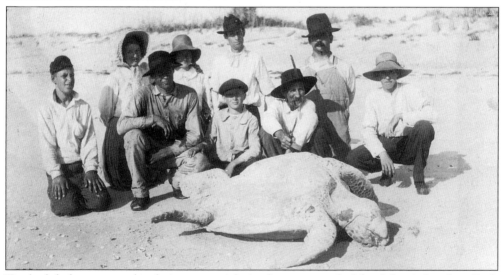

Turtles left the ocean to lay their eggs at night in the warm sand of the Atlantic beaches. Both the turtles and their eggs were highly prized by local residents as exotic and delectable meals. This creature was truly an endangered species judging by the salivating group of onlookers that surrounded her. This scene was typical of many played out on the beach near Oceanus in 1910.

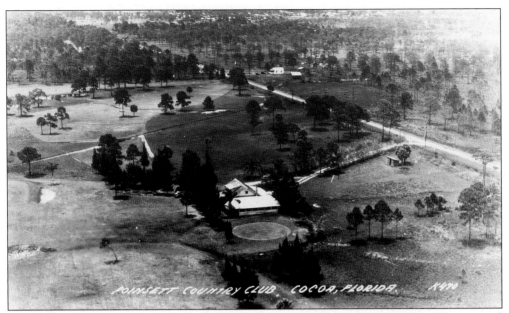

This 1940s aerial view of the Poinsett Country Club in Rockledge shows the broad fairways and greens that delighted golfers of the period. Now known as the Rockledge Country Club, this private club on Fiske Boulevard is the place to look for Brevardians relaxing or conducting business.

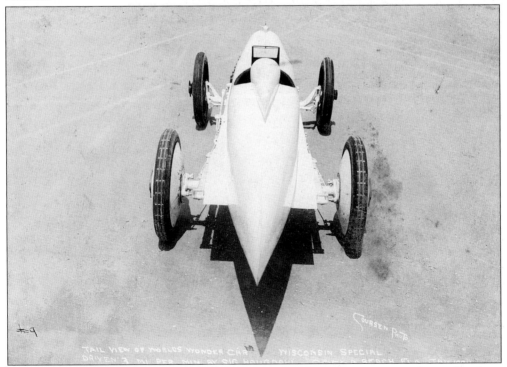

The "World's Wonder Car" recorded a sizzling 180-mile-an-hour pace on Cocoa Beach in January 1924. Sig Haugdahl was the driver. Local crowds were thrilled to witness the daring spectacle of man and machine challenging the elements at such a high rate of speed.

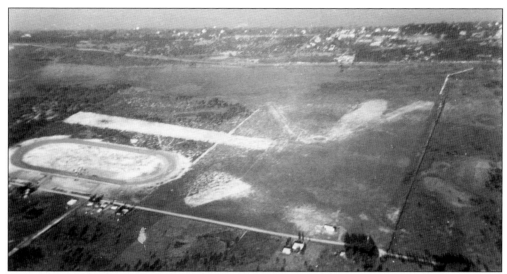

This 1947 aerial view of the race track and airport catches the sporting flavor of life in Cocoa. The street running from left to right in the foreground is Pineda Street. The straight line to the right is a drainage ditch. This location is now School Street going east from Pineda Street. Racing in Cocoa started after WW II, and continued in popularity for a few years. Some of the local residents involved in racing were E.M. Crisman, Turk Atkins, Jimmy Thompson, Sam Furnari, Johnny Fortenberry, Jim Ponder, and Harold Williams.

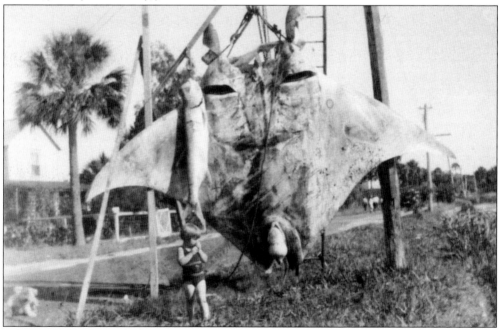

What a catch! This male devil fish, weighing 3,500 pounds and measuring 16 feet and 4 inches from tip to tip, was harpooned off Cape Canaveral in 1933. The devil fish towed the boat for 12 miles before it was landed. A 6-foot tarpon looks like a sardine when compared to this "monster of the deep!" The successful fishermen were James B. Pinkerton, Charles Williams, Cooper Williams, and Lyle Turner. The small girl in the picture is Mattie Ruth Williams Atkins, daughter of Cooper Williams.

Six
COMMUNITY SNAPSHOTS

Central Brevard County was progressive in its outlook, and many of the "firsts" in the county occurred in Cocoa or Rockledge. The first bridge to span the Indian River and link the mainland with the barrier islands was built in Cocoa in 1916–17. Hiram Smith Williams, a pioneer in the Rockledge Community, was the president of the first telephone company in the county. Cocoa and Rockledge both boasted early airports, and each town was an aggressive player in the Florida boom of the early 1920s.

The easily navigable waters of the Indian River brought hundreds of sailing vessels and yachts to the area each year. Presidents Grover Cleveland and Warren G. Harding took advantage of the hospitality of the area. With the opening of the Dixie Highway in the 1930s, thousands of tourists passed through the region annually, and many who were impressed with the progressive outlook of Cocoa and Rockledge stayed or built winter homes. From New York, Michigan, Ohio, and other northern states, an annual influx of long-term visitors added to the cultural mix. Even today, central Brevard County reflects the impact these individuals had on the shaping of the community.

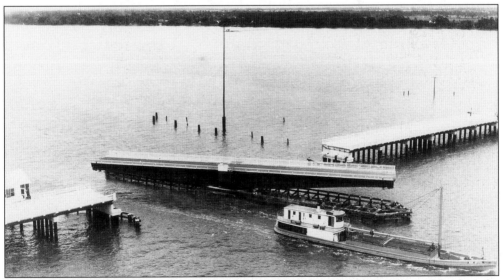

This picture of the draw bridge over the Indian River at Cocoa, with Merritt Island in the background, shows the bridge tender's house at the left. The bridge tender's job was a 24-hour-a-day position and required him to be available at all hours of the day and night. With the coming of the Space Center, the increased traffic on the bridge and the larger volume of river traffic imposed considerable delays on both land and water vehicles. When the bridge's turning mechanism got stuck in the open position, delays of up to several hours meant unmet appointments and tardy workers.

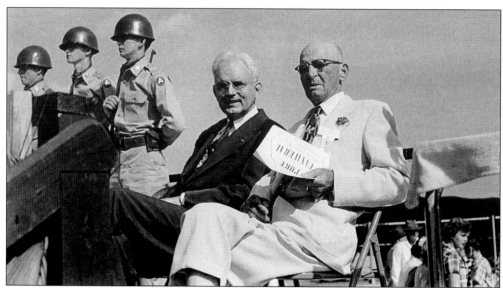

After years of planning and dreaming of a port at Canaveral, the port became a reality with its dedication on November 4, 1953. Although the talk of such a facility first surfaced in the early 1920s, construction did not begin until June 1950. Since there was no natural bay or port at this location, the port is entirely man-made. The soil removed by the dredging operations was used to create the Highway 528 causeway, named for Medal of Honor winner Emory Bennett. Col. Noah Butt, pictured here with Senator Spessard Holland, served two separate terms as mayor of Cocoa (1928 and 1942). He was the Brevard County attorney for more than 20 years and served six years in the Florida Legislature. While a member of the legislature, he introduced the measure that required operators of motor vehicles to have a license. "Colonel" was an honorary title.

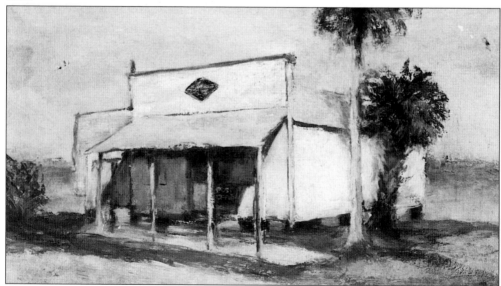

This painting by the late Narcissa Perrin shows the Abney and Abney General Store at City Point, north of Cocoa at the east end of City Point Road. The City Point post office was located in this building, and the mail was delivered to the post office by mail steamer. At one time, City Point, which no longer exists, was larger than Cocoa.

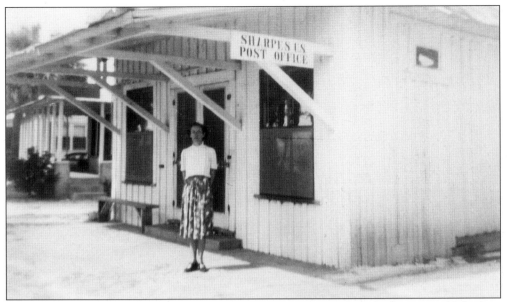

Charlotte Jenkins was the postmistress of the Sharpes Post Office, which was established on April 4, 1890. Originally located on the banks of the Indian River for easy access to mail boats, the post office was later moved west of today's U.S. Highway 1.

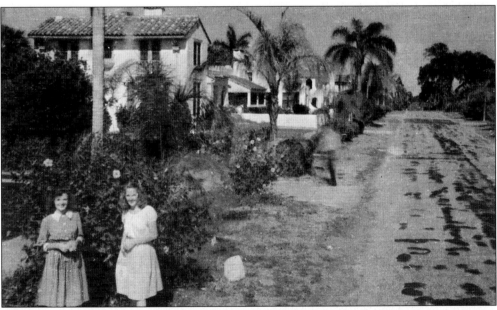

This view shows the 1920s Valencia Road Homes subdivision, developed by C. Sweet Smith and others. Local architect Richard W. Rummel Jr. designed the Mediterranean Revival homes that mirrored those by Addison Mizner in Boca Raton and "Doc" Davis in Temple Terrace and Davis Isle in Tampa. The actual construction of the houses was largely done by William Hervey "Herbie" Bower. The young lady at the left is Marian McMurtrey, and current Melbourne resident June Gettings Geiger is pictured on the right in this photograph from the 1950s.

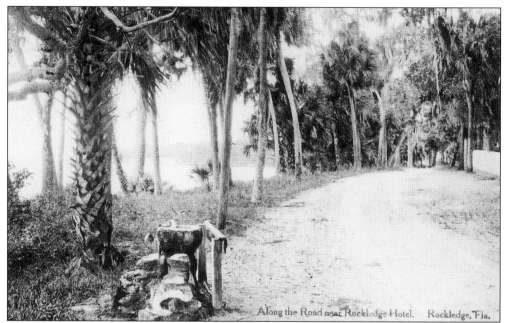

Along the Road near Rockledge Hotel. Rockledge, Fla.

This drinking fountain on the banks of the Indian River stood in front of the home of Hiram Smith Williams on Rockledge Drive south of Barton Avenue in Rockledge. Williams, one of the earliest settlers of Rockledge, harnessed an artesian well for passersby and their horses to quench their thirst.

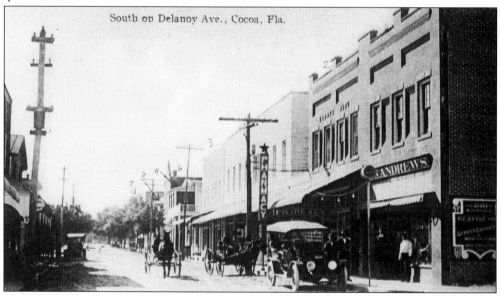

South on Delanoy Ave., Cocoa, Fla.

This picture was made in front of the Travis Hardware building and looks south on Delannoy Avenue. The store on the right belonged to L.S. Andrews and sold clothing. The Red Star Pharmacy is identified by the sign with the star. This street was originally called Front Street and was the first street from the Indian River. Subsequent dredgings of the Indian River channel have extended the banks of the river eastward. Delannoy Avenue is now a one-way street; when this picture was made the street was heavily used by vehicles, which parked on either side of the street.

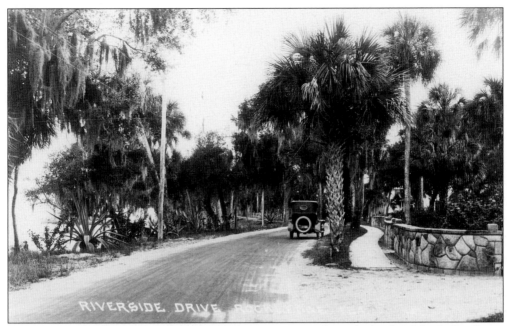

Originally called Palmetto Avenue, Riverside Drive curves along the banks of the Indian River in Cocoa. Its original name came from the numerous palmetto plants that had to be cleared from the land before it could be used. Since waterfront property is always more desirable as a building site, this area was home to the more affluent citizens of the town. The coquina fence on the right gives mute testimony to the money spent on erecting the fine homes of the wealthy.

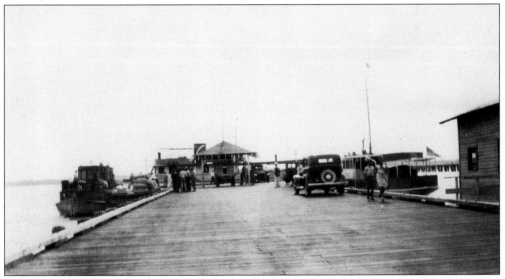

The Cocoa City Dock was a busy place in the 1930s as this photographs shows. The first bridge to Merritt Island can be seen on the right. The entrance to the bridge provided an auspicious place for Bennett's Seafood and Bait Shop. The dock was in good repair when the first causeway was dredged for Highway 520, and the structure was incorporated into the causeway. Many local people who "remember the wooden bridge" are actually referring to this structure and not the original 1917 bridge.

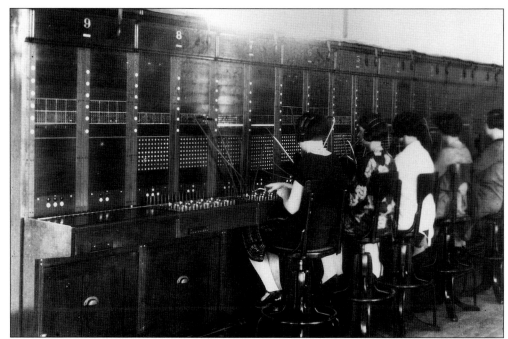

Cocoa's telephone switchboard was located in a building at the corners of Delannoy Avenue and Maryland Avenue. All telephone calls were routed through an operator who routinely asked, "Number, please?" Early numbers were one, two, or three digits, although occasionally a letter would be added at the end for a party-line number.

Today's Ashley's Restaurant was designed by architect Richard W. Rummel Jr. and was known as Jack's Tavern. Owner Jack Allen and Rummel specified that masons laying bricks on the building should not "cut" the excess mortar from the face of the bricks. D.C. "Red" Brannen, a mason, said that not following through with the normal practice of "cutting" was the hardest part of the job. Contrary to popular legend, the building was never used as a train depot. Through the years, various operators have changed the name of the structure to such quaint titles as "The Mad Duchess," the "Sparrowhawk," "Cooney's Tavern," and "Gentleman's Jim's." The building is said to be haunted by the ghost of a young woman, and her story has been publicized in numerous books and television features.

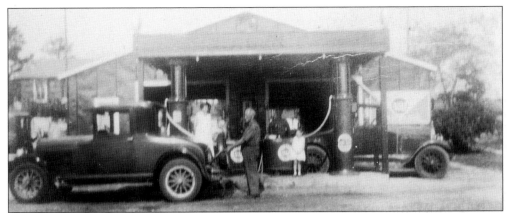

Sterling's Garage was located south of Barnes Road on the east side of U.S. Highway 1 in Rockledge. This photograph, taken around 1932, shows the building with its original awning, which had been lost when the road was widened. Pictured here, from left to right, are Elsie Sterling, Emond Sterling (pumping gas), and Elsie Roesch Smith. This was one of the oldest garages in operation on Florida's east coast. Notice also the glass tank at the top of the pump, which measured the amount of gasoline delivered to the customer.

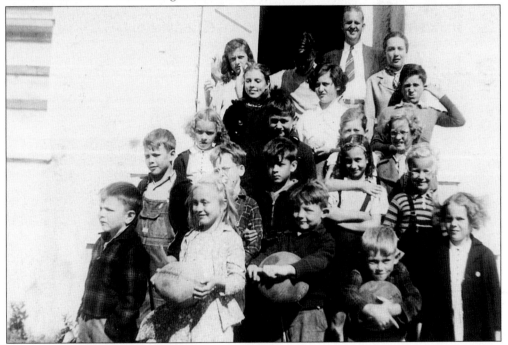

The one-room Cape Canaveral School housed students in grades one through six. This picture of the student body of 1938–39 was among the last taken since the school closed in the early 1940s, when better transportation made it easier for students to attend schools in Cocoa. The site is now part of the Kennedy Space Center complex. The students are, from left to right, as follows: (front row) Jessie Hill, Donna Jandreau, Lee Chamberlain, Freddie Jandreau, and Patsy Evans; (second row) Ira Hill, Roger Dobson, Benjie Lewis, Delores Morgan, and Florence Holmes; (third row) Dorita Evans, Melvin Tucker, Gloria Whidden, and Beverly Dobson; (fourth row) Noni Knutson, Kathyrn Morgan (Mask), and Tommy Willis; (fifth row) Jane Lewis, Jack Mask, and Betty Mae Jeffords; (back row) Mr. Evans (teacher).

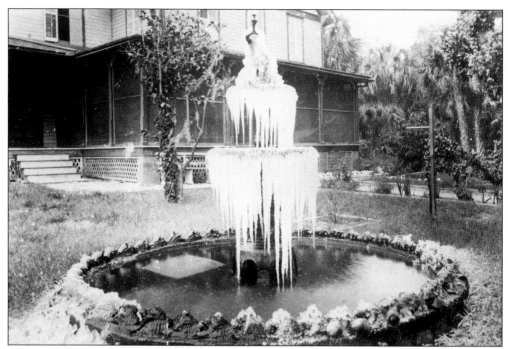

The central Brevard area is not immune from cold weather as this 1894–95 picture shows. This frozen fountain, located in front of the Hiram Smith Williams house in Rockledge, looks like some artist's creation. The freeze of 1894–95, followed immediately by a freeze in 1896, severely crippled the citrus industry in Florida. The grove of Capt. Douglas Dummett, across the Indian River from Titusville on Merritt Island, was largely unscathed, and his grove provided buds and stock for a re-born citrus industry.

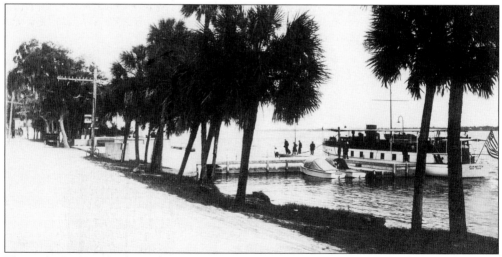

The yacht *Zianetta* was home-based in New York. Her owner brought her down the coast to the Indian River and docked her at the Indian River Hotel dock. There have been four Indian River Hotels at this site on Rockledge Drive north of Barton Avenue. Despite the many changes, the Indian River Hotels always enjoyed reputations as being the very best of the resort hotels. As such, they were patronized by many wealthy and influential guests. The Indian River Condominiums now occupy the site of the once-stately hotels.

Seven

Transportation: Steamboats and Railroads

The arrival of the small steamboat Pioneer in 1877 signaled a remarkable change in the Indian River area. Within ten years, more than 200 larger vessels plied the Indian River on regular runs. Capt. T.J. Lund, who owned the Pioneer, is owed the credit for opening the area to commerce and travel and for changing the somnambulant lagoon into a beehive of commercial activities. Steamboats provided a vital, dependable link to northern markets for local residents. The regularity of their runs changed central Brevard County into a hub of citrus growing, truck farming, cattle raising, and fishing, and they promoted the growth of tourism to a degree that was only exceeded with the coming of the railroad.

Steamboats also added a colorful cultural dimension to the entire Indian River area. Steamboat captains, like Steve Bravo, were the objects of admiration and became heroes to thousands of youngsters along the lagoon. The steamers brought entertainers, traveling evangelists, doctors, lecturers, and, most important, mail to a population starved for something new and exciting. Up and down the river, crowds turned out to greet the arrival of steamers, to view the passengers who ventured south, and to make arrangements for their commercial enterprises. Henry Flagler, the great railroad baron, is credited with developing the east coast of Florida, but for that 140-mile stretch from Titusville to Jupiter Inlet, the credit rightfully belongs to Capt. T.J. Lund.

Capt. Steve Bravo, the skipper of a number of Indian River steamers, was a popular folk hero to people along the Indian River. From Jupiter Inlet to the Haulover Canal, the tales of his derring-do grew with each voyage he made down the 140-mile-long lagoon. Tourists and natives, young and old, marveled at his ability to spin yarns about the Indian River and its boats. After long service with Henry Flagler's Overseas Railroad, Captain Bravo ended his nautical career as the director of the Port of Miami.

THAT INDIAN RIVER CAPTAIN

I saw him just a year ago
Methinks I see him yet;
His tall and sinewy form erect
His keen bright eye of jet.

I hear his drawling accents
As he paces night and morn;
The deck of the *St. Sebastian*
Spinning each prodigious yarn.

To regale the Northern tourists
Who, unlearned in Southern lore;
Swallow more or less of fiction
With each wonder they explore.

While the Jolly Captain Bravo
Laughs and chuckles in his sleeve;
As he thinks of some new story
For the Yankees to believe.

----Anonymous

This poem, published in the Titusville *Star Advocate*, captured Captain Bravo in rhyme. While tongue-in-cheek, the words do portray an accurate picture of the popular captain.

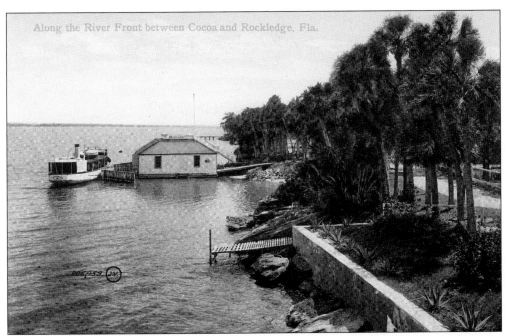

Since the early settlers along the shores of the Indian River depended on river traffic for commerce, news, and social activities, each family had a long dock stretching far out into the lagoon. These docks and boathouses along the river between Cocoa and Rockledge provide an insight into the many purposes each dock served.

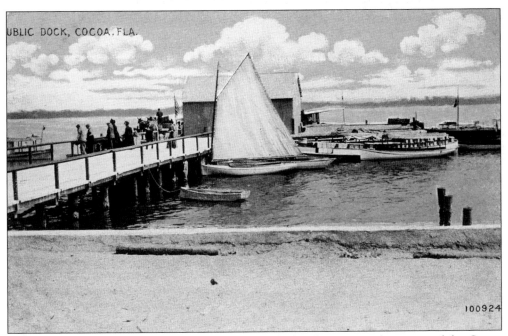

UBLIC DOCK, COCOA, FLA.

100924

Each city or village along the river had a central dock. This is an early picture of the Cocoa Municipal Dock, where steamboats landed to take on passengers and freight and to discharge their cargoes of goods and people.

This later view of the Cocoa Municipal Dock, located at the foot of Harrison Street, gives the viewer an indication of the warehouses and packing houses that were used to store citrus products, fish, and other items of commerce.

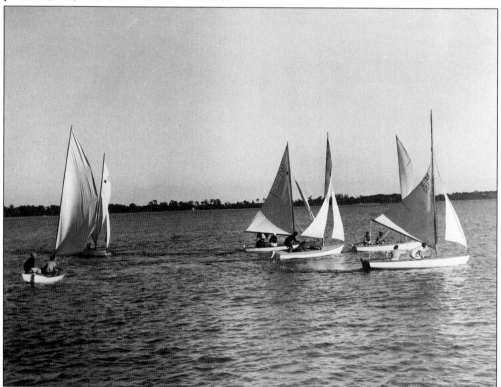

Indian River-class sailboats were indigenous to the lagoon. These particular boats were built in the Cocoa High School woodworking shop presided over by shop teacher Chet E. Hoyt.

The logo of the Indian River Steamboat Company, the largest of the companies operating on the Indian River, captures the pioneer nature of the river. The company later became insolvent and closed down its operations.

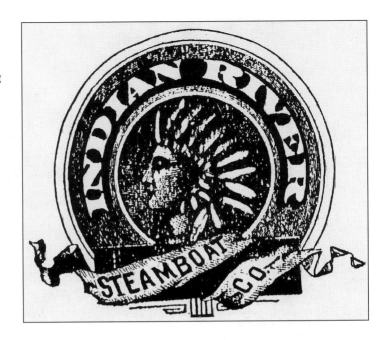

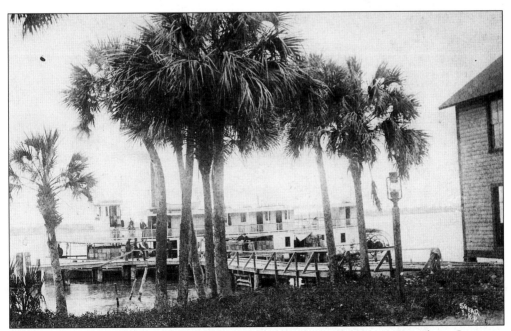

The *Georgiana*, an Indian River freighter operated by the Indian River Steamboat Company (IRSC), is docked at the Hardee Wharf in Rockledge. The IRSC named its steamers after communities along the river.

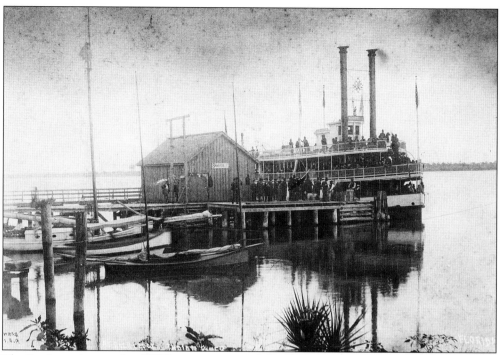

The *St. Augustine*, another IRSC steamer, was 110 feet long, but its steel hull had a draft of only 36 inches. Here, the *St. Augustine* takes on passengers for an Indian River excursion.

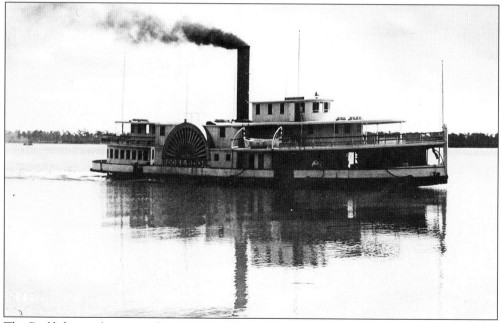

The *Rockledge* was known as the "Queen of the Indian River" when she was placed into service in July 1886. The steamer's iron hull was 136 feet long and pulled a shallow draft of barely 30 inches. In 1888, President Grover Cleveland and members of his wedding party visited the Indian River area, and the *Rockledge* carried them from Titusville to Rockledge and back. "It was," said local historian Fred A. Hopwood, "her finest hour."

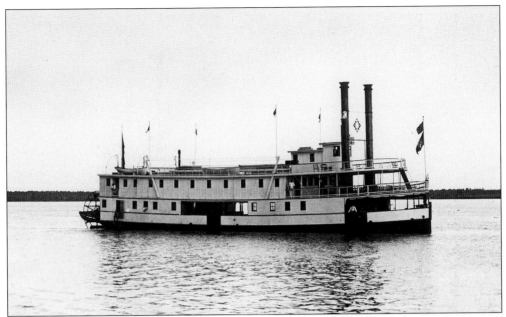

The *St. Lucie* replaced the *Rockledge* as the "Queen of the Indian River." The *St. Lucie* featured staterooms that were 6 feet by 6 feet, a dining salon, a saloon, and a number of fishing and shooting stations from her upper decks. Under the command of Capt. Steve Bravo, the *St. Lucie* looked majestic with her freshly painted decks and gleaming smokestacks.

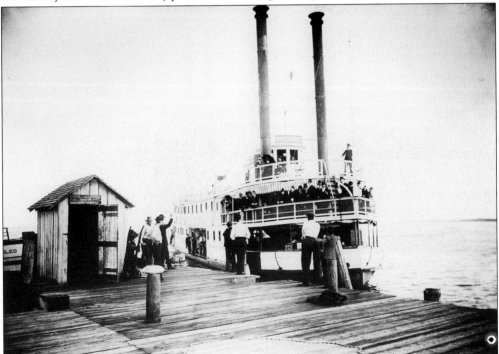

The *St. Lucie* could safely handle 150 passengers, but she sometimes carried more. Passengers filled every available space on excursions, including space on the lower cargo deck. To the left, the nameplate of the small mailboat *Cleo* can be seen behind the dock shed.

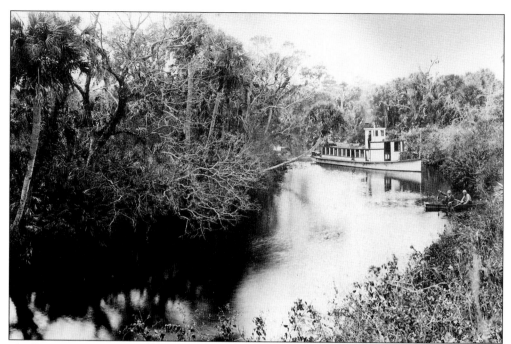

Small steamers, like the mailboat *Cleo*, could negotiate the lesser creeks and tributaries of the Indian River. The *Cleo* and other steamers of her size delivered the mail, ferried schoolchildren to the mainland, and hauled citrus from island groves. The *Cleo* had the distinction of being the first steamer built entirely in Brevard County. Her captain was A.W. Buie.

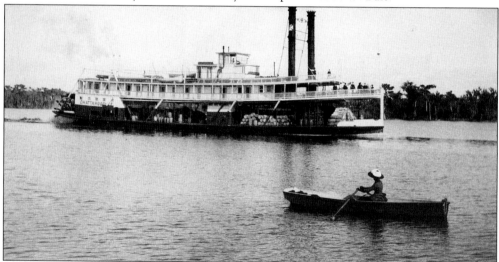

The *Chattahoochee* was a freighter that plied the river as part of the Indian River Steamboat Company fleet. She hauled large cargoes of building materials and commercial goods south on the river and returned north with citrus, truck crops, and fish. The *Chattahoochee* was purchased by Henry Flagler and used as a floating hotel for workmen busy extending the Florida East Coast Railroad to Palm Beach and beyond. The lady in the foreground is simply rowing to visit her neighbors in her finest clothes. Virtually every family on the shores of the Indian River owned a rowboat or a sailboat of some description, and children as young as four years of age were allowed to sail the river by themselves.

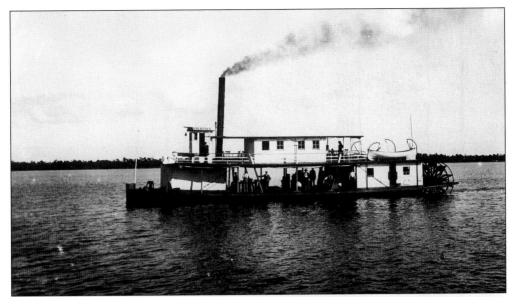

In 1893, Indian River residents were delighted with the appearance of the small steamer *Courtney*. With the coming of the railroad in the early 1890s, the role of steamboats changed, and the *Courtney* saw service as a mailboat, schoolboat, and ferry. Although named after the Merritt Island community of Courtenay, the spelling of the steamer's name was slightly different.

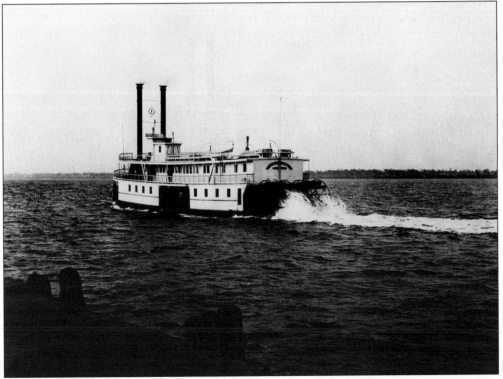

The *St. Augustine* was regarded as one of the prettiest steamboats on the Indian River run. Her 24-foot beam gave her great stability during the storms that sometimes hit the area.

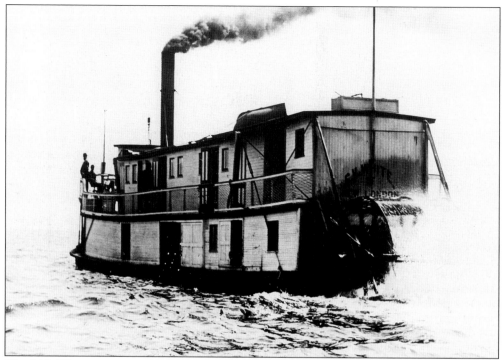

The *S.V. White* was constructed in Georgia and brought to the Indian River area. Too small to handle more than an occasional passenger, the *White* was used primarily as a mailboat. On March 21, 1891, the steamer capsized near the small community of Coquina, south of Rockledge. She was later re-floated and put back into service.

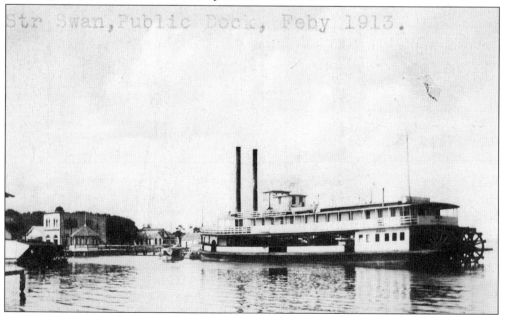

The *Swan*, a 20th-century steamer, ties up at the Cocoa Municipal Dock in February 1913. Some of the buildings in the background are still being used today in the busy commercial life of Historic Cocoa Village.

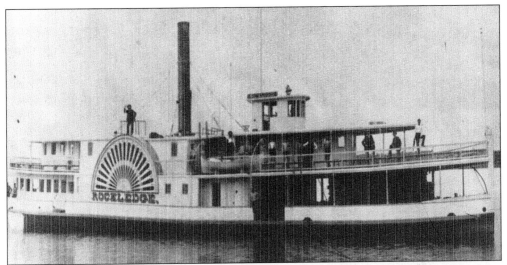

Once the stately "Queen of the River," the *Rockledge* ended its days as a floating gambling den on the Miami River. When she became too decrepit for this unseemly role, she was towed out into Biscayne Bay and sunk with dynamite charges.

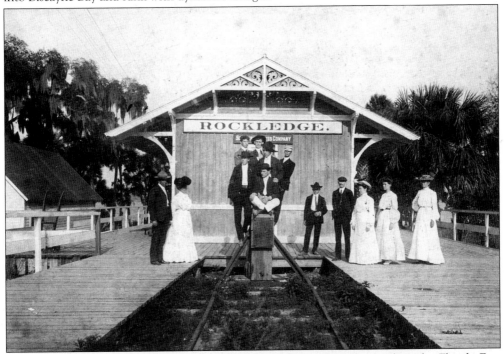

The end of the first cycle of steamboating on the Indian River came when the Florida East Coast Railroad (FEC) pushed its tracks along the shores of the Indian River southward to Palm Beach, then to Miami, and even further to Key West. The FEC depot was located on the Indian River at the foot of Orange Avenue in Rockledge. This location allowed patrons of the Hotel Indian River and the Plaza Hotel to reach their destination in just a few short steps. Local residents in this picture include the mother of the late Roy Packard (first on right), Vera Hibbs Packard (third on right), and Roy Packard (first man on right). O.K. Key and Morris Weinberg are also pictured. The first through train from Jacksonville to Rockledge arrived in 1893.

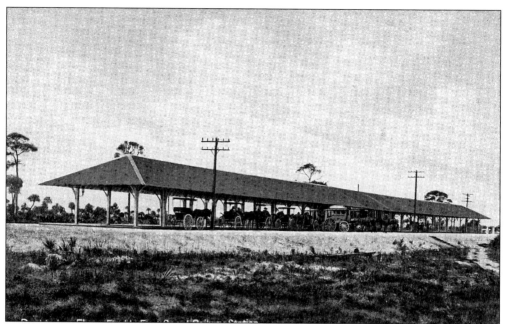

This is the Florida East Coast Railroad depot in Rockledge after it was moved west of town near present-day U.S. Highway 1.

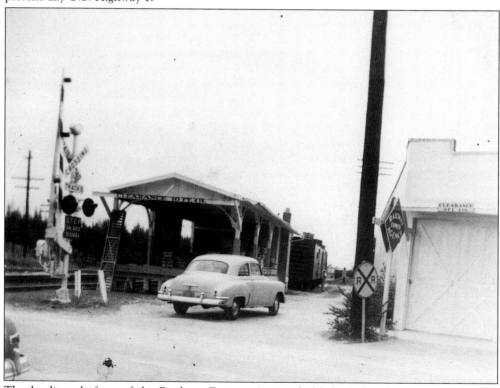

The loading platform of the Raulway Express Agency holds bushel baskets of citrus in this 1950s photograph. The prompt delivery of citrus illustrates the critical role the railroad played in the economic development of the Indian River area.

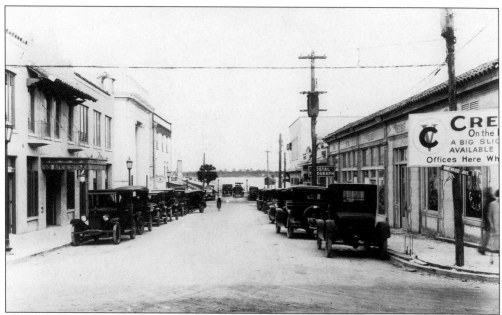

This 1920s picture of busy Harrison Street in Cocoa is a terrific composite of four critical elements to keeping the residents of the town in the mainstream of America. First, rapid communications were important, and the Postal Telegraph Company office on the right and the Western Union office on the left meant that the world was instantly connected to Cocoa. The wide variety of automobiles show the importance of newly created roads and highways to the commerce of the town. In the distance, the Cocoa-Merritt Island bridge meant that once-isolated areas of central Brevard County were now reachable for visitors, settlers, and business people.

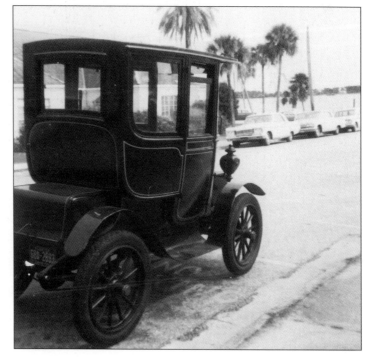

Miss May C. Quimby, known as the "Blue Lady of Rockledge," drove this 1912 Baker Electric car as she went about her business in Cocoa and Rockledge. She owned and operated the Woman's Exchange on Barton Avenue in Rockledge. She was referred to as the "Blue Lady" because of a medical condition that gave her skin a blue cast.

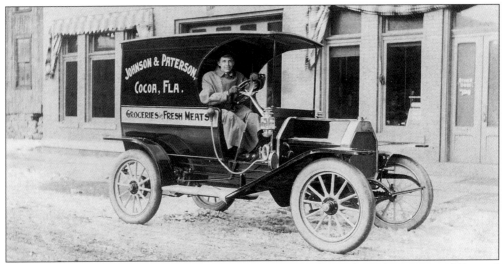

Although the Johnson and Paterson Grocery Store was located at the corner of Brevard Avenue and King Street in Cocoa, this delivery truck made it possible for the store to serve a large number of customers who phoned in their orders. This early grocery store had no electronic cash register or scanner to automatically ring up prices. Instead, the clerk would gather your purchases, place them on the counter, take out a heavy brown paper sack (a customer was never asked, "Paper or plastic?"), list your purchases and the prices on the sack, total the order, collect the money or write it up in the credit book, and then package your groceries in the same sack. Along with every in-store purchase or delivery, customers were given a large dose of local facts and gossip free of charge!

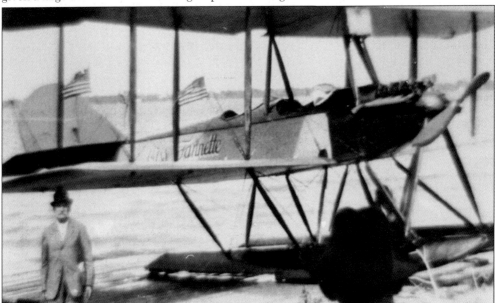

The hydroplane *Miss Fanette* was pictured in the Cocoa *Tribune* of March 15, 1923. Owned by Davis Winn, the hydroplane was brought to the former Rockledge golf course (now the site of Wuesthoff Hospital) and converted into a land-based airplane. Passengers and pilots wore helmets and goggles, which were helpful in warding off the ill-effects of an open and unheated cockpit.

Eight

CITRUS AND OTHER AGRICULTURAL PURSUITS

The name "Indian River" has become synonymous with quality citrus fruits throughout the world. These fruits, renown for their sweet taste and juicy pulp, have become the standard by which citrus is judged. It is a reputation that is well deserved.

Following the devastating freezes of 1895–96, buds and cuttings from the Dummett Grove near Cape Canaveral provided the stock for the revival of the entire citrus industry in Florida. Grove owners spent great amounts of time and money in developing the Indian River varieties and in marketing them to the public. Great packing houses lined the banks of the lagoon, and steamboats hurried to and fro with huge cargoes of citrus destined for northern markets. In a later period, long lines of freight cars filled railroad sidings, and trucks and wagons, accompanied by workers, loaded crate after crate after crate to satisfy the demand for Indian River fruit. Along tourist routes, small stands and packing houses offered passersby an opportunity to pick fruit or to buy it already packed for shipment.

Although many of the smaller groves along the Indian River no longer exist, the demand for quality citrus continues unabated. Today, giant companies or combines have replaced the small grove owner, and the internet has taken the place of the small family-operated roadside stands. A few such places still exist, but, they, like the dinosaur, will soon pass away.

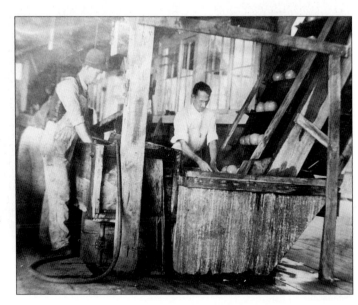

Washing citrus fruit removed the debris left by the exposure to the elements in the grove and made the fruit more appetizing for potential consumers. E.P. Porcher, a wealthy Cocoa citrus factor, invented this machine to make the task easier and used it in his packing houses.

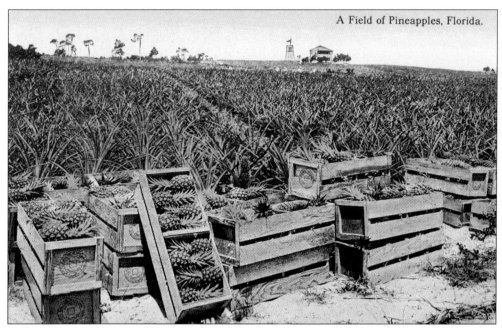

A Field of Pineapples, Florida.

Early settlers of the Indian River grew pineapples commercially before they concentrated on citrus fruits. In the early 1890s, the Indian River area produced more pineapples for the American market than any other area. Devastating freezes and the overthrow of the Hawaiian monarchy by American planters in the mid-1890s brought an end to this profitable enterprise.

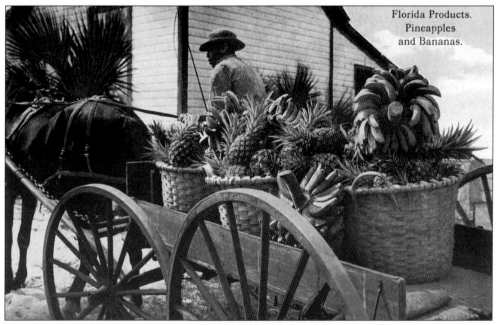

Florida Products.
Pineapples
and Bananas.

Even bananas were grown commercially along the banks of the Indian River. Pineapples and bananas required intensive manual labor to harvest and a quick route to markets. The Indian River steamboats provided the access to markets, while the labor came from migrant workers.

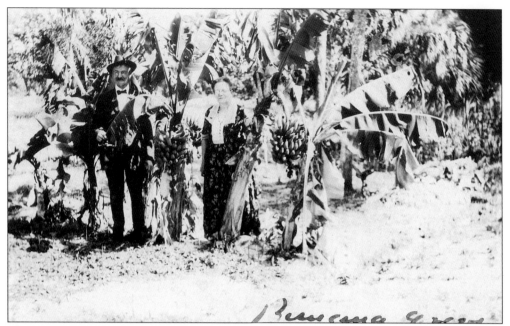

This picture of the Poinciana Grove shows how well bananas grew in the region. American growers soon lost this lucrative market to Central American planters, who grew bananas on huge plantations.

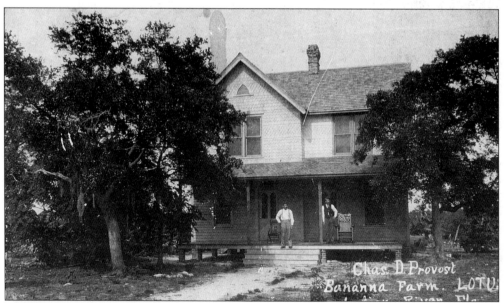

Charles D. Provost, a local merchant, also operated a successful banana grove in the small community of Lotus. The well-constructed family home in the background is evidence of how much money could be made in this sector of the Indian River economy.

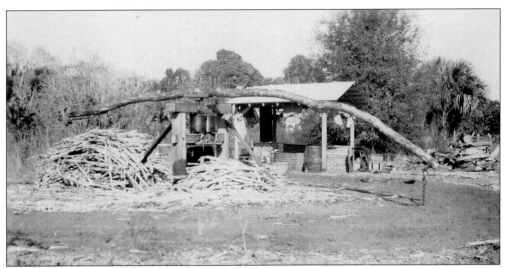

Early settlers, such as the Joe Field family at Indianola, relied on sugar cane to add a supply of sweetener to the family's diet. This cane mill, like hundreds of others along the river, pressed the sweet cane juice from the stalks. The juice would then be boiled to produce molasses, sorghum, or sugar. Cane grindings were often social events, made even more pleasurable when some of the "squeezings" were allowed to ferment to produce a mildly alcoholic brew.

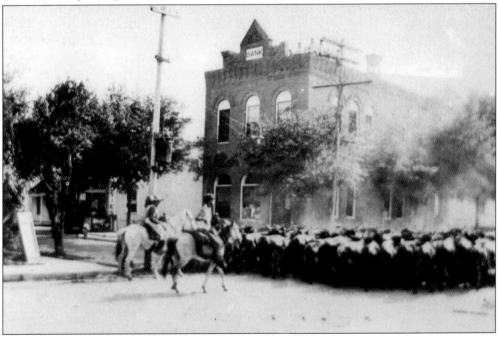

Prior to 1918, cattle owners on Merritt Island allowed their cattle to roam free. Ownership of individual animals was noted by a brand seared into their hide. When a fence law was passed for the island, few individuals saw much profit in continuing to raise cattle in the confined areas of the island and sold their animals to the Platt family, Brevard County's largest ranchers. The newly constructed Cocoa-Merritt Island Bridge provided an easy way for the Platts to move the cattle across the Indian River, through the streets of Cocoa, to the marshes of the St. John's River, about 10 miles inland.

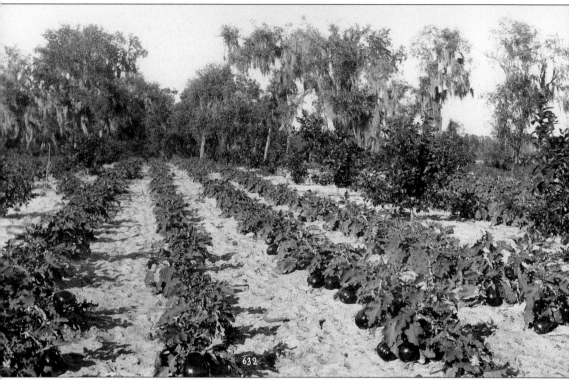

The rich soil of the Indian River hammocks supported a variety of truck farming operations. These beautiful eggplant vines, planted among rows of young citrus trees, are laden with large and succulent eggplants destined for northern tables.

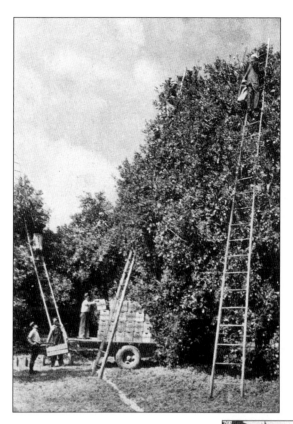

Citrus workers harvested fruit in wooden boxes for transportation to the packing shed, where the fruit would be washed, graded, and re-packed for commercial markets.

Harvesting ripe citrus for market required hundreds of constantly moving hands. Long ladders ensured that the fruit from the very top of the trees was gleaned. These workers at the Cannatta Grove in Georgiana had to balance precariously on the ladder, extend themselves to reach the fruit, and carry a heavy shoulder bucket to hold the fruit, while keeping a wary eye out for wasps and other biting insects. Female family members inspect the harvest and throw out any damaged fruit.

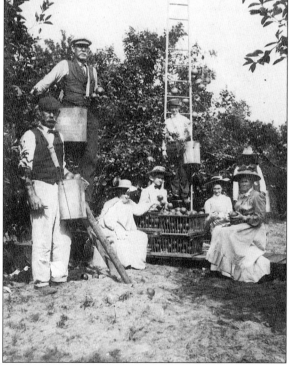

When the time came to harvest citrus, everybody worked. Joe Cannatta, the owner of the Cannatta Grove at Georgiana, joins hired workers in picking oranges.

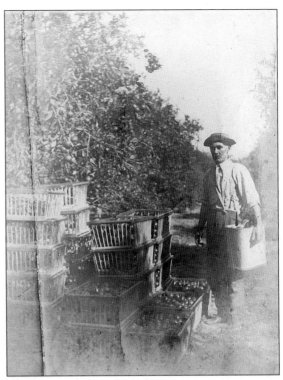

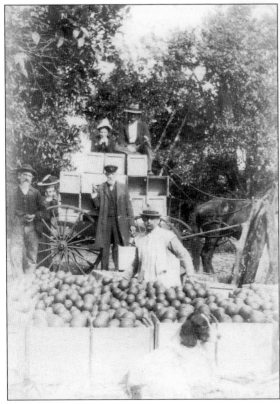

Joe Cannatta, the grover owner, and his family pose in front of crates of Indian River oranges in this turn-of-the-century photograph.

Citrus groves not only provided an annual income for the grove owner's family, they provided a beautiful place for Sunday strolls and social events. Here are two young members of the Cannatta family, Louise and Helen, enjoying a Sunday outing.

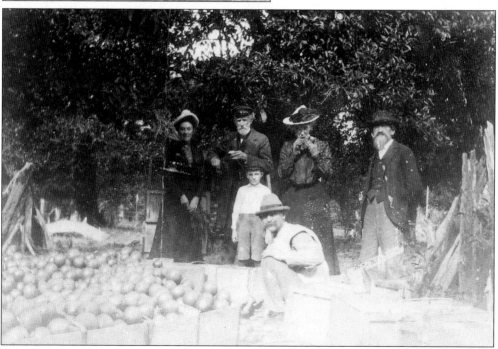

Citrus trees and harvested fruit provide the background for this portrait of the Cannatta family of Georgiana in the early 1900s.

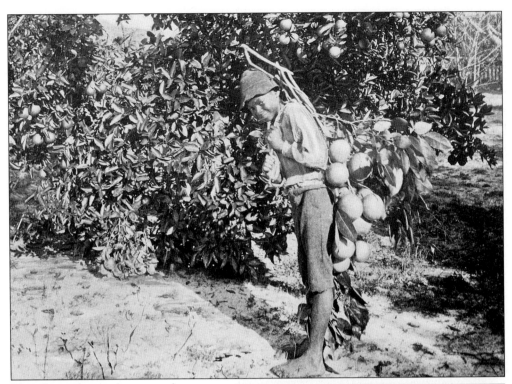

This obviously posed picture of a young African-American worker in a Rockledge citrus grove was part of an advertising brochure that subtly conveyed the message that the Rockledge area was great for growing citrus and had an abundant supply of grove workers.

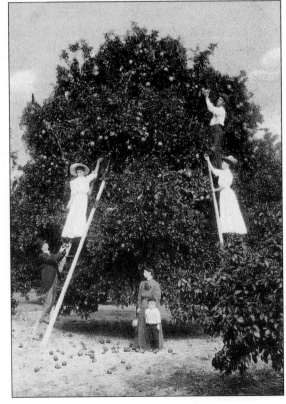

The citrus groves provided tourists an opportunity to enjoy the unusual experience of picking oranges. This 1909 postcard was widely distributed throughout the United States. What tourists enjoyed for a few minutes was hard work for those who harvested the crop on an annual basis.

This anonymous worker was known as a "nailer." Packing houses employed such men to assemble the wooden boxes used to pack and ship fruit to market. After the crates were full, the "nailer" nailed the wooden tops securely. The tool he is using was called a box hatchet. "Nailers" had to be fast and proficient, since fruit packers were paid by the number of crates packed, and a slow or inefficient "nailer" could cause the packing line to come to a halt. Good "nailers" were in demand by packing house owners and greatly appreciated by packers. This picture was taken in the E.P. Porcher Packing House in Cocoa.

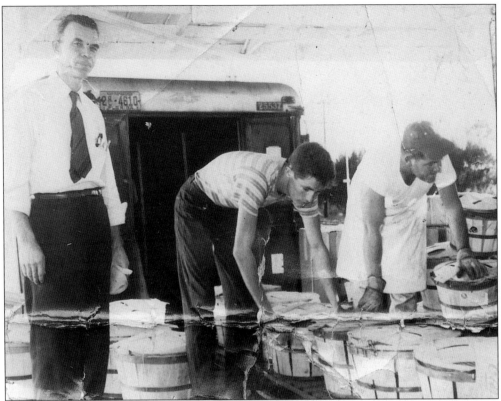

R.L. Murrell, the Railway Express agent at Cocoa, supervises workers as they load crates for shipment in the early 1950s. The man in the middle of the picture is unidentified. The worker on the right is Dean Mink, a well-known Cocoa resident.

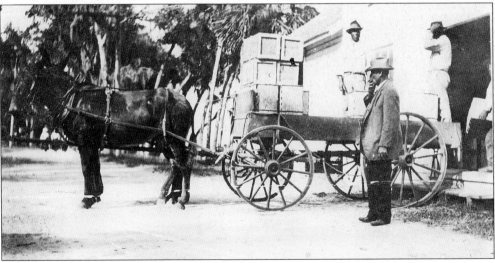

Gardner S. Hardee, a Rockledge grove owner, is shown in front of the original Pioneer Groves Packing House in the early 1880s. Pioneer Groves was established in 1868 and was a successful venture for many years. Hardee was a prominent civic leader and served as a state senator for several terms.

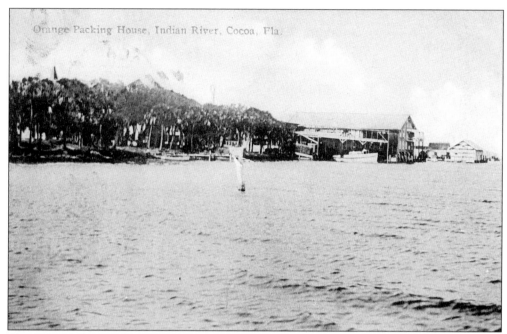

The E.P. Porcher Packing House stood on the west bank of the Indian River in downtown Cocoa. The packing house was located just north of the family's palatial home on Delannoy Avenue.

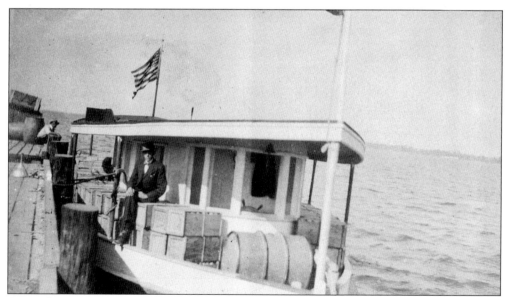

During harvest season, every available space on river steamers and freight cars was utilized to haul fruit to markets.

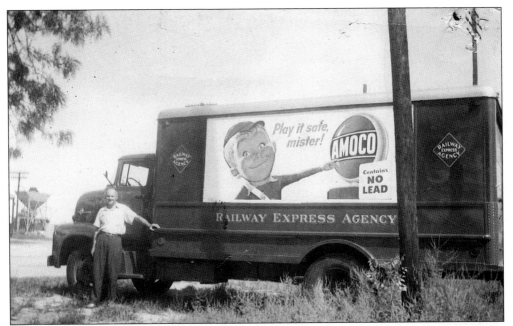

An unidentified worker of the Cocoa office of the Railway Express Agency stands beside his truck near Poinsett Drive. These trucks were used to pick up crated fruit from the packing houses and haul them to the Express depot.

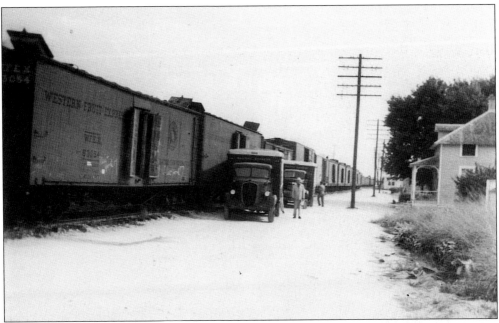

Freight cars stand idle in this 1930s photograph as workers await the delivery of packed citrus destined for northern markets. This scene was repeated at scores of railroad sidings throughout the Indian River region every year.

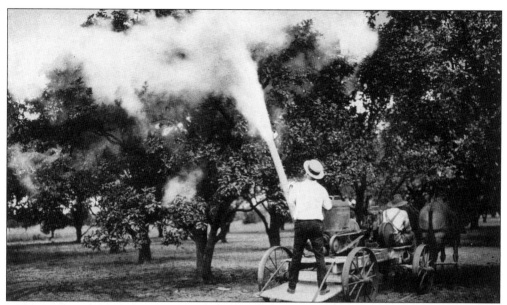

Citrus trees needed a great deal of care throughout the year. Workers carefully weeded around the base of trees and removed "suckers" from branches. Other workers laid irrigation pipe and monitored the amount of water available to each tree. Here, two workers spray a chemical dust to kill insects that might attack the developing fruit.

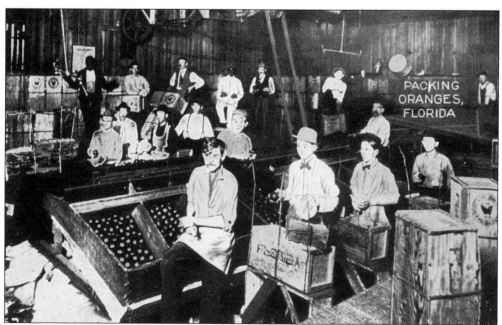

A turn-of-the-century packing house employed many workers. It is doubtful that the workers wore bow ties every day, but the special occasion of this photograph encouraged them to look their best.

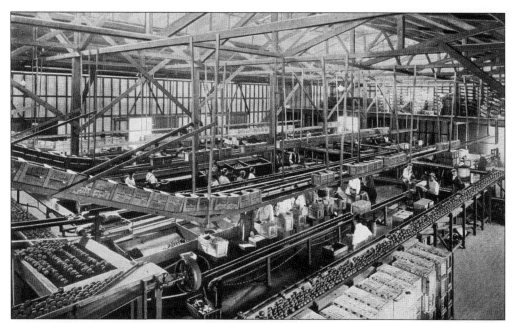

As packing houses became more modern, they employed much more machinery than their predecessors, but the process of sorting, grading, washing, and packing the fruit remained the same. Each orange or grapefruit was wrapped in tissue paper, and a typical crate held between 100 and 250 oranges.

Not everyone worked in the citrus industry. Pretty local resident Rachel Duke Bobowicz poses on the rear bumper of the Black Cat Dry Cleaning and Shoe Repair van parked on Oleander Street. The movie theater, now the Village Playhouse, is in the background, and a sidewalk sign informs customers that shoes can be half-soled for only 75¢.

Harvey's Groves, first started in 1925, has been a family-operated business for more than 70 years. Today's packing house and retail outlet is a familiar sight to motorists on U.S. Highway 1, south of Rockledge. Originally started by Roy and George Harvey, the citrus operations passed to George and Janetta Harvey. Today's successful business is under the supervision of their sons, Larry and Jimmy. A fourth generation is already receiving training in grove operations.

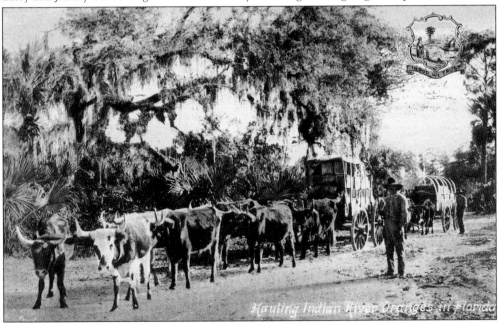

Early citrus farmers in central Brevard used the Indian River Express, a collection of ox-drawn covered wagons, to move their crops northward. This method was very slow, but once the wagons cleared the Indian River area, they could connect with railroads and ships at Palatka on the St. John's River.

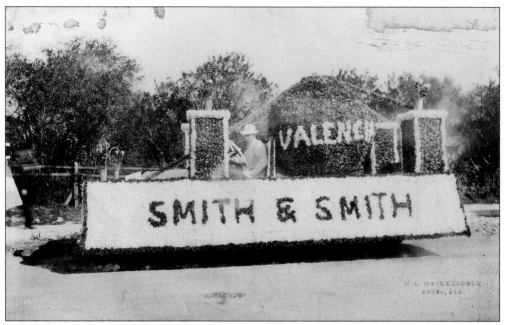

The Orange Jubilee Celebration, an annual event in Cocoa, celebrated the citrus industry. This parade float was sponsored by Smith and Smith and featured a giant Valencia orange. The Smith brothers, along with Horace Bruen and L.S. Andrews, were the developers of the Valencia Road subdivision in Rockeldge.

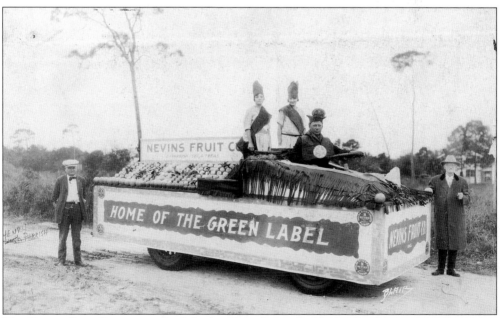

The Nevins Fruit Company, which had packing houses in Titusville, Cocoa, and Fort Pierce, was one of the largest citrus producers in the Indian River area. H.U. Parrish, the general manager, is pictured at the extreme left of the photograph.

H.U. Parrish, manager of the Nevins Fruit Company, was elected the king of the first Orange Jubilee Celebration on January 10, 1935. Jean Highfill was crowned queen. The Orange Jubilee featured a parade, boat races, sports contests, and other activities during the several days it lasted. In the mid-1920s, a similar event called the Orange Festival was held for two years and then abandoned following the Florida bust. The first king of that short-lived event was "Uncle Bob" Geiger.

WELCOME !

TO THE

Indian River Orange Jubilee

A. R. Trafford, Inc.

A. R. TRAFFORD, Pres.

L R. HIGHFILL, MARSTON T. MILLER
Associates

ROBERT SNAPP, Acreage Specialist

OUR CONTINUOUS BUSINESS

SINCE 1917

ASSURES YOU OF OUR

INTEGRITY AND RELIABILITY

— WE SOLICIT YOUR LISTINGS —

OFFICE

Harrison Street Phone 66

Program of Events

INDIAN RIVER ORANGE JUBILEE

Cocoa, Florida

Thursday, Friday and Saturday
January 10, 11 and 12, 1935

This Orange Jubilee Is Arranged for the Purpose of Glorifying the Indian River Orange, and Entertainment of Winter Visitors and People of Brevard County

ARRANGED AND SPONSORED AS ONE OF THE
ACTIVITIES OF THE
GREATER COCOA CHAMBER OF COMMERCE

HONORARY COMMITTEE OF ORANGE JUBILEE
HON. DAVE SHOLTZ, Governor of Florida
Chairman

COL. MARIE HOLDERMAN Governor's Staff	LANSING GLEASON Mayor of Eau Gallie
HON. J. J. PARRISH State Senator	J. I. CROWDER, Pres., Merritt Island, Peninsula Asso.
HON. MARK WILCOX Congressman	A. FORTENBERRY County Commissioner
R. W. MALONE Mayor of Cocoa	W. C. KLINGENSMITH County Commissioner
W. J. DARDEN Mayor of Titusville	A. A. DUNN County Commissioner
E. P. JOHNSON Mayor of Rockledge	JOHN B. RODES County Commissioner
DR. I. K. HICKS Mayor of Melbourne	C. SWEET SMITH County Commissioner

HON. N. B. BUTT, Representative in State Legislature

The program for the 1935 Indian River Orange Jubilee listed prominent state and regional politicians, including Gov. Dave Scholtz, as members of the honorary committee of the Orange Jubilee. Aside from its entertainment value for "Winter Visitors and People of Brevard County," the jubilee was held for the purpose of "Glorifying the Indian River Orange."

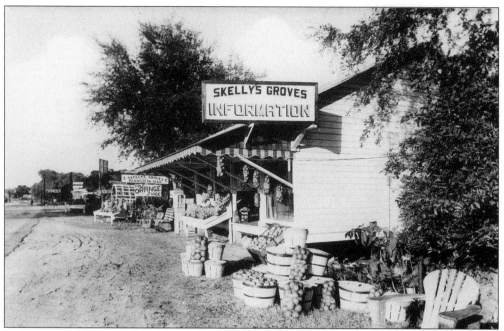

Skelly's Groves, originally established in 1868, provided tourists with information about the area, an opportunity to pick fruit from trees, and an opportunity to purchase packaged fruit from the Skelly Packing House.

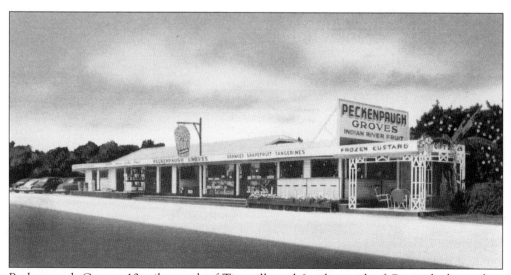

Peckenpaugh Groves, 12 miles south of Titusville and 6 miles north of Cocoa, had a modern merchandising operation on U.S. Highway 1. Northern tourists stopped at such places to take a break from the tedium of driving the two-laned highway.

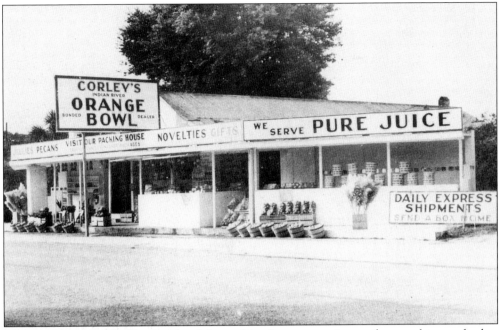

Corley's Orange Bowl offered tours of the packing house operations, gifts, novelties, and other items. Tourists could stop, purchase a box of fruit, and have it shipped home to envious friends or relatives in the northern states.

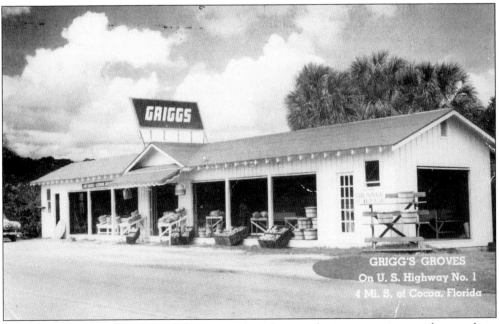

Grigg's Groves, 4 miles south of Cocoa, combined its marketing operations with a working packing house. The wide diversity of such operations along U.S. Highway 1 provided winter visitors with a number of new and exciting sights in these pre-Disney days in Florida.

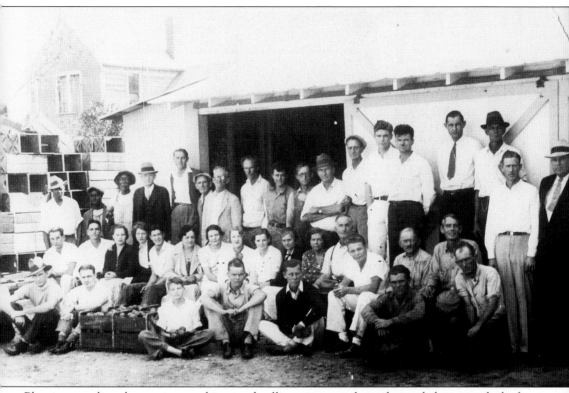

Planting, tending, harvesting, packing, and selling citrus products demanded a great deal of time and lots of labor. Here the workers for the Indian River Citrus Exchange on Florida Avenue in Cocoa gather for a group shot.

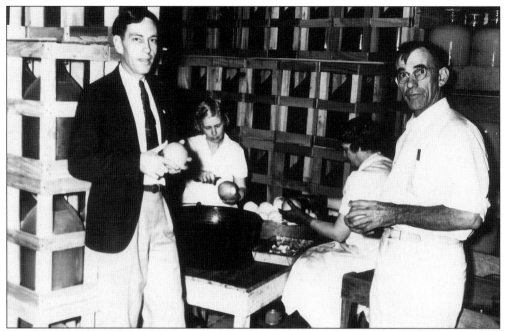

The Lapham Jelly Company, located on North Tropical Trail on Merritt Island, produced a wide variety of jellies, candies, and preserves for sale to tourists and local residents. Douglas Gibbons (left) and Fred Humphrys (right) examine fruit being prepared for cooking by two unidentified ladies.

Neil Humphrys tests a vat of jelly at the Lapham Jelly Company factory on Merritt Island. The chief product of this company was their famous guava jelly.

Papayas, such as these grown by South Merritt Island resident Charlie McIntosh, were sold to local merchants and also filled bins in the many citrus outlets along U.S. Highway 1.

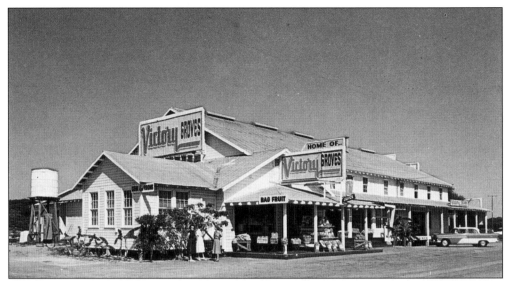

The Victory Groves Packing House on U.S. Highway 1 in Rockledge is on the National Register of Historic Places (1993). The building was built in 1930 by Marion S. Whaley, an early citrus grower in the area. During WW II, the building was expanded and the name changed to Victory Groves. Frank Sullivan purchased the operation from Whaley and changed the name to Sullivan Groves, but locals continued to refer to it as Victory Groves. Sullivan went out of business in 1998, and the building is being renovated once again by its new owner.

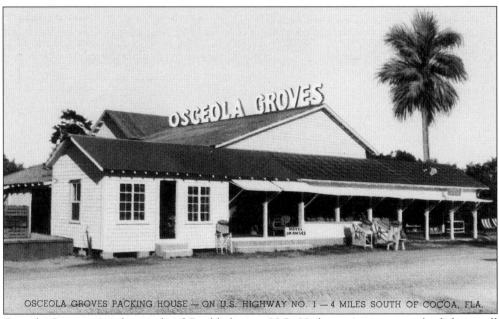

OSCEOLA GROVES PACKING HOUSE — ON U.S. HIGHWAY NO. 1 — 4 MILES SOUTH OF COCOA, FLA.

Osceola Groves, 4 miles south of Rockledge on U.S. Highway 1, was typical of the small roadside operations that catered to tourists. With the creation of the Space Center at Cape Canaveral, many small grove owners sold their acreage to developers for the construction of houses for space workers. The opening of the I-95 interstate highway was the final blow for the remaining small operators, and they closed their doors and went out of business.

Nine
WORLD WAR II AND AFTER

WW II ushered central Brevard County into the 21st century. With the construction of the Banana River Naval Air Station in 1939, central Brevard County prepared to join the rest of the world in the great conflict. That war was imminent for Americans was never in question, since central Brevardians simply had to visit Cocoa Beach to witness the human drama played out in miniature as German U-boats attacked freighters hauling essential war materiel from Central and South America to Great Britain. That war had arrived was never in question as witnessed by the scores of pathetic seamen, survivors of torpedo attacks, who struggled ashore singly or in groups, bedraggled, frightened, and grateful for having survived. That war would take a toll on young central Brevardians was also never in question as parents and loved ones steeled their hearts and brains to the possible outcome when the United States did go to war. Their worst fears were realized on December 7, 1941.

WW II also had a positive effect on central Brevard County. The paychecks of young soldiers, sailors, and fliers brought a new prosperity to the region and provided a counterbalance to the impact of the Depression. The planes and chemicals of the Navy brought the mosquito population under control. After the war, the military's concern with improving on German rocket science and the creation of what would ultimately become the Kennedy Space Center provided jobs and a continuing economic boom. The thousands of scientists, engineers, and support persons meant a constant expansion of roads, stores, and public facilities. It was a challenge that Brevard County accepted and met.

Residents of Cape Canaveral and Cocoa Beach were spectators to the submarine attacks on coastal freighters during the early 1940s. The *LaPaz*, torpedoed off Cape Canaveral, was towed toward shore and sank just off the beach at the end of today's Highway 520. Included in its cargo holes were about 900 cases of Johnny Walker Scotch whiskey. Many residents who were employed to help salvage the cargo remember the event fondly and still talk about the whiskey, which escaped into private hands. The *LaPaz* was raised, towed to Jacksonville for repair, and continued to serve throughout the war.

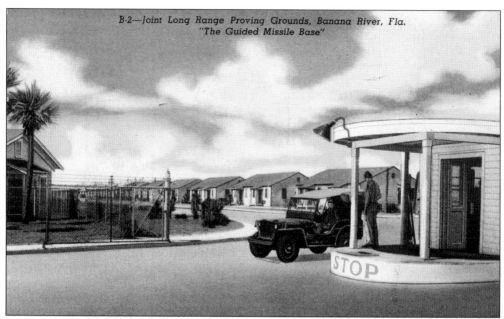

The Banana River Naval Air Station was built in 1939, two years before the entry of the United States into the war. Its amphibian planes conducted anti-submarine searches of the Atlantic Ocean. When the war was over, the Banana River Naval Air Station was the headquarters for the Joint Long Range Proving Grounds for missiles. Today's Patrick Air Force Base occupies much of the site of the old air station.

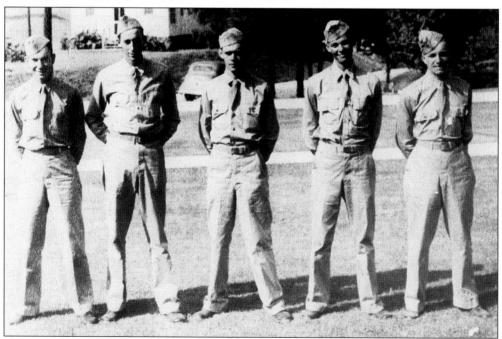

When war came, Brevardians served. This 1942 picture captures the youthfulness of several prominent Cocoa residents of today. Pictured, from left to right, are Edgar Pritchett, Bobby Cowart, Jack McMahon, Oliver Bossom, and Henry U. "Hugh" Parrish Jr.

124

Central Brevard County lost sons in WW II. The faces of this group of "Gold Star Mothers" reflect both the pride they feel for having sons who served and the sadness they experienced at their loss. Many central Brevard County residents lost their lives in this conflict. Among the dead were Alta Paul Ashurst Jr., Joe R. Avant, Marvin H. Booth, Gary T. Cooper Jr., Ernest B. Lay, Henry C. Newbern, William Gordon Paterson, Edward W. Peckenpaugh Jr., Charles W. Pettis, Charles K. Seawright, Thomas Royal Smith, and Clay Stephens.

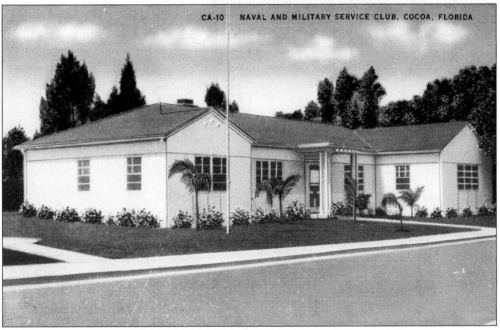

This building was originally built as the Naval and Military Service Club in Cocoa. It was located on Brevard Court where today's post office stands. In the postwar years, it served as a center for teenagers and as a library.

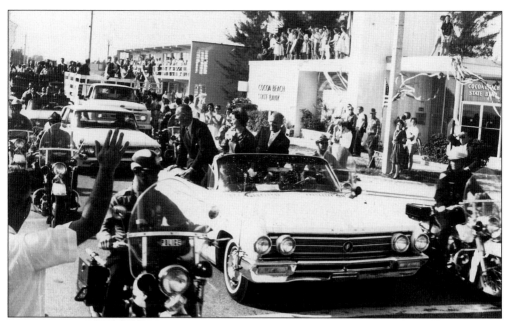

Central Brevardians turned out in large numbers to greet astronaut John Glenn on his return to his point of departure, following his three-orbit journey around the world. Glenn, his wife, Annie, and Vice President Lyndon B. Johnson wave in response to the acclamation of the crowd. The motorcade was accompanied by a motorcycle escort, secret service men, and trucks carrying cameramen and reporters.

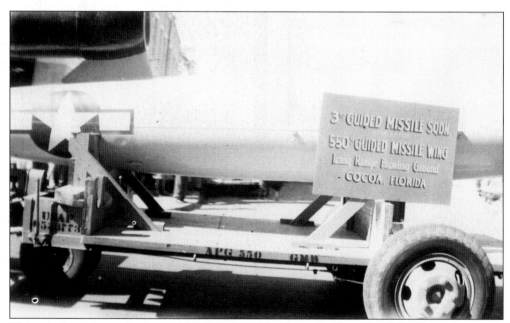

This missile on its trailer bore a startling resemblance to the "buzz bombs" of Nazi Germany. Captured V-1 and V-2 rockets were brought to the Space Coast for testing and modification into guided missiles for the American military. The military brought out the weapons for public parades and patriotic events.

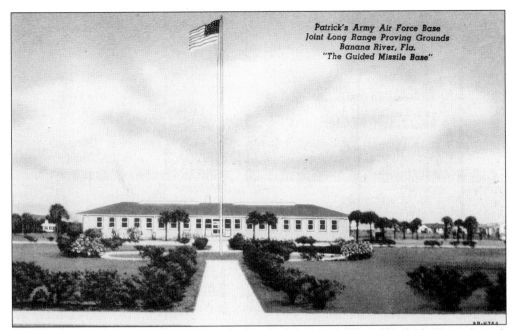

This 1950s picture of the administration building of America's "Guided Missile Base," Patrick Air Force Base, was widely circulated. As the intensity of the Cold War increased, the use of such photographs was restricted for fear that some military secret might be revealed.

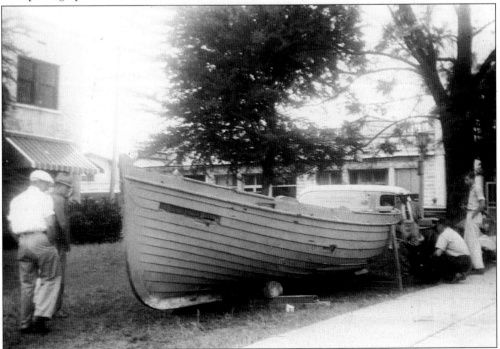

This lifeboat from an English freighter torpedoed by a German U-boat near Canaveral Light House was riddled with machine gun bullets. It was displayed at the corner of Brevard Avenue and King Street in Cocoa, as seen here in 1942, with a banner that encouraged citizens to "Buy Bonds."

The United States Air Force Missile Test Center's Technical Laboratory, with its display of American rockets, offered motorists on U.S. Highway A1A a capsule history of the nation's rocketry program in a few hundred yards. Salt spray from the Atlantic Ocean rusted most of these rockets, and they were removed for safety reasons.

Brevard County was one of the last Florida frontiers to be settled. On July 20, 1969, Neil Armstrong, Edwin "Buzz" Aldrin, and Michael Collins opened a new facet of the frontier when they ventured to the moon. Armstrong would become the first human to set foot on that faraway orb.